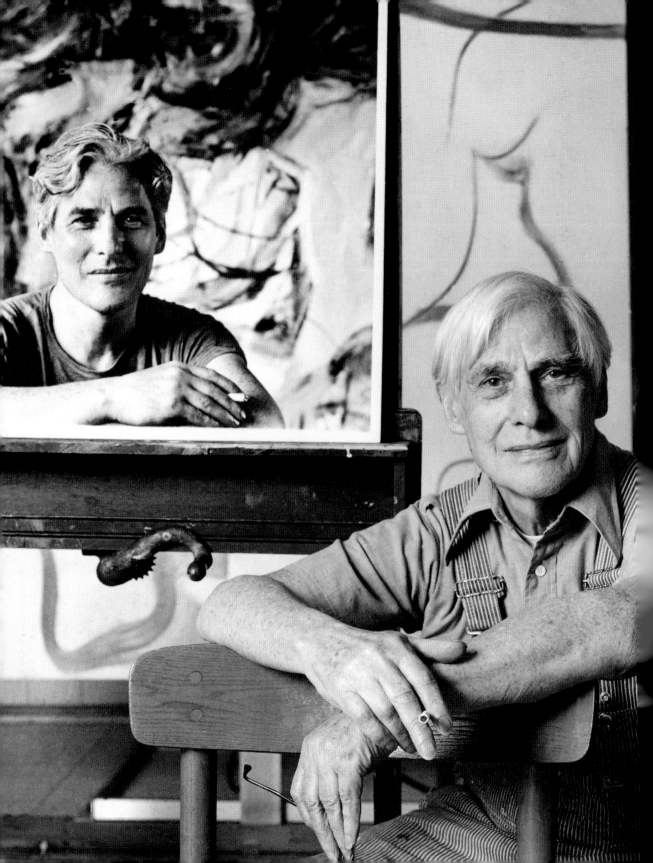

Barbara Hess

WILLEM DE KOONING

1904–1997

Content as a Glimpse

TASCHEN

HONG KONG KÖLN LONDON LOS ANGELES MADRID PARIS TOKYO

COVER:
Palisade, 1957
Oil on canvas, 200.7 x 175.3 cm
Private collection

BACK COVER:
Willem de Kooning, 1953
Photograph by Hans Namuth

ILLUSTRATION PAGE 1:
Woman (Blue Eyes), 1953
Oil and crayon on paper, 71 x 51 cm
New York, Collection of Samuel and Ronnie Heyman

ILLUSTRATION PAGE 2:
Willem de Kooning, 1983
Photograph by Hans Namuth

To stay informed about upcoming TASCHEN titles,
please request our magazine at www.taschen.com/magazine
or write to TASCHEN America, 6671 Sunset Boulevard, Suite 1508,
USA–Los Angeles, CA 90028, contact-us@taschen.com, Fax: +1-323-463.4442.
We will be happy to send you a free copy of our magazine
which is filled with information about all of our books.

© 2007 TASCHEN GmbH
Hohenzollernring 53, D–50672 Köln
www.taschen.com
© The Willem de Kooning Foundation/VG Bild-Kunst, Bonn 2004
Project management: Petra Lamers-Schütze, Cologne
Coordination: Christine Fellhauer, Cologne
English translation: John Gabriel, Worpswede
Production: Ute Wachendorf, Cologne
Layout: Catinka Keul, Cologne
Cover design: Catinka Keul, Cologne

Printed in Germany
ISBN 978–3–8228–2135–0

Contents

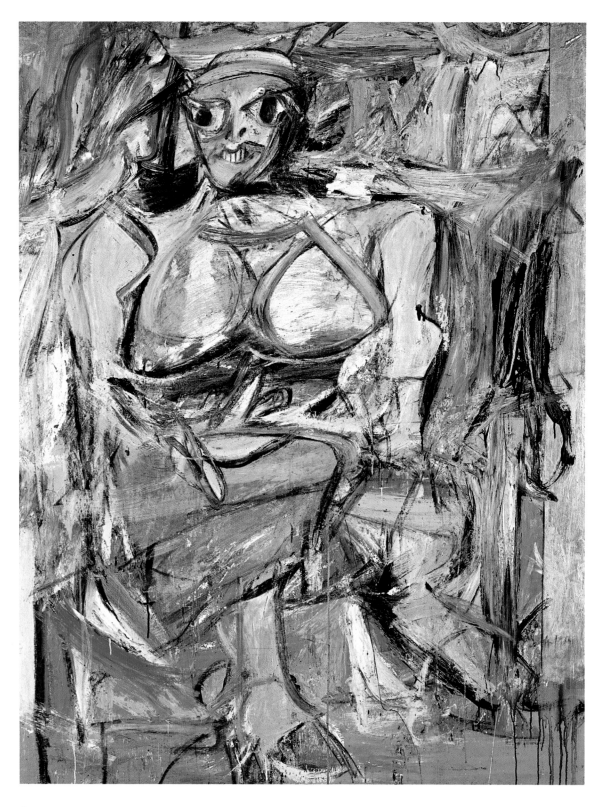

Willem de Kooning: An Erasure

"It was nothing destructive. I unwrote that drawing because I was trying to write one with the other end of the pencil that had an eraser."

Robert Rauschenberg, in 1953 a young, twenty-eight-year-old artist, showed courage when he asked the master of Abstract Expressionism for a drawing, saying he intended to erase it. Willem de Kooning, then forty-nine and on the verge of world renown, had no objection. The drawing he gave Rauschenberg to erase was done in ink with traces of crayon. Rauschenberg invested a month's work before finally declaring the result to be his own art. The erasure negated de Kooning's drawing in a twofold sense. It caused it to vanish at the same rate as the eraser strokes Rauschenberg "wrote over" it preserved it: a self-contradictory gesture of identification and rejection.

In the early 1950s, New York developed into a cultural center of new movements. The art scene, strongly influenced by European émigrés, such as Marc Chagall, Marcel Duchamp, Max Ernst and Yves Tanguy, was just as much in a state of turmoil as the political world. New York's population grew to over seven million; a wave of Puerto Rican immigrants reached the city, settling on the West Side. As never before, New York life was a unique mixture of promise and despair, poverty and success stories.

By 1953, Willem de Kooning was well on his way to the pinnacle of the art world. After Jackson Pollock, to use de Kooning's own words, "had broken the ice," Abstract Expressionism, a term first used in *The New Yorker* in 1946, began its meteoric rise. Following the "Ninth Street Show," a group exhibition curated by Leo Castelli in May 1951 that brought the Kooning to prominence, in 1953 the artist mounted his third one-man show; that same year a first retrospective was even on view in Boston. In spring 1953, de Kooning had his first one-man show with Sidney Janis, a then already highly influential dealer of avant-garde art. De Kooning soon reigned supreme in the New York art world of the 1950s. As the art critic Irving Sandler recalled, "De Kooning was admired for his integrity and dedication to art – qualities which were thought by many (including me) to be embodied in his painting."

Rauschenberg's 1953 erasure brought the crossing of the lifelines of two artists of different generations and cultural backgrounds (de Kooning was then still a Dutch citizen, at least on paper). That year also marked the onset of a struggle between Paris and New York for priority in contemporary art. As art historian

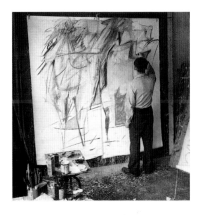

Willem de Kooning in his Manhattan studio drawing *Woman I*, 1950
New York, the Estate of Rudy Burckhardt

ILLUSTRATION PAGE 6:
Woman I, 1950–52
Oil on canvas, 192.8 x 147.3 cm
New York, The Museum of Modern Art

Robert Rauschenberg
Erased de Kooning Drawing, 1953
Traces of ink and crayon on paper, in mat with
label inscribed by hand in ink, in gold leaf
frame, 64.1 x 55.2 x 1.3 cm
San Francisco, CA, San Francisco Museum
of Modern Art. Purchased through a gift of
Phyllis Wattis

"In the 50s and early 60s, to see Bill on the
street downtown was to witness a vision whose
aura eclipsed even his own shadow."
ROBERT RAUSCHENBERG, 1989

Serge Guilbaut once put it, a "war of pictures" began to rage between the two
countries.

Increasingly the postwar world, with the foundation of NATO and the pass-
ing of the World Trade Agreement, was perceived as a global playing field for art
as well. In the late 1950s the French critic Michel Seuphor wrote, "Abstract art
is so successful that it is in the process of shaping the face of our century." The
status of the artist was enhanced to that of an international representative of hu-
manistic values. "Every intelligent painter," wrote Abstract Expressionist artist
Robert Motherwell on the occasion of a 1951 exhibition of the New York School,
"carries the whole culture of modern painting in his head. It is his real subject,
of which anything he paints is both a homage and a critique, and everything he
says is a gloss."

As the United States began to play a dominant role in world politics, its art,
too, set out to become a global player. American artists attempted to overcome
the overweening ideal of Europe, by tapping new sources of imagery and dis-
covering indigenous roots. The self-confident actors in this movement might
be likened to engineers and firemen on the locomotive pulling the train of art
history, their eyes focused on the rails ahead and stoking the fire for all it was
worth. "Perhaps when, like Ingres or de Kooning, an artist is able to invent his
own form, the shapes themselves retain the energy that went into their creation
and they store it like coal stores fire," wrote de Kooning's biographer, Thomas
Hess, in the late 1950s. The engine was stoked not only by artists such as Franz
Kline, Barnett Newman and Jackson Pollock but, of course, also Willem de
Kooning. The movement was aided and abetted by curators at the Museum of
Modern Art, New York, by gallery owner and collector Peggy Guggenheim, by
the magazine *ARTnews* and its editor, Thomas Hess, and by art critics like Dore
Ashton, Clement Greenberg and Harold Rosenberg. As de Kooning stated at the
outset of his seminal lecture "The Renaissance and Order" in 1950, "There is a
train track in the history of art that goes way back to Mesopotamia. It skips the
whole Orient, the Mayas, and American Indians. Duchamp is on it, Cézanne is
on it. Picasso and the Cubists are on it, Giacometti, Mondrian and so many,
many more – whole civilizations."

What played out on the canvases of Abstract Expressionists like de Kooning
and Pollock as the Cold War cast its shadow over the world was not only a battle
for preeminence on the art scene. It was also a struggle to project a world picture
that was capable of coming to terms with the devastating blow to civilization
that was World War II. Rational thinking had miserably failed, and had revealed
its cruel, inhumane side. Reason, as an ethical corrective, seemed to have lost all
validity. How could art react to this state of affairs? For de Kooning, the only
possible reply was to look at things close up. The painting that caused a scandal
and established his reputation, *Woman I* (p. 6), virtually presses the viewer's nose
into the paint, the "flesh" of the painting embodied in expressive gestures. "Flesh,"
de Kooning declared in 1950, "was the reason oil painting was invented."

ILLUSTRATION PAGE 9:
Woman, 1952
Pastel and pencil on paper, 53.3 x 35.6 cm
Collection of Thom Weisel and Emily Carroll

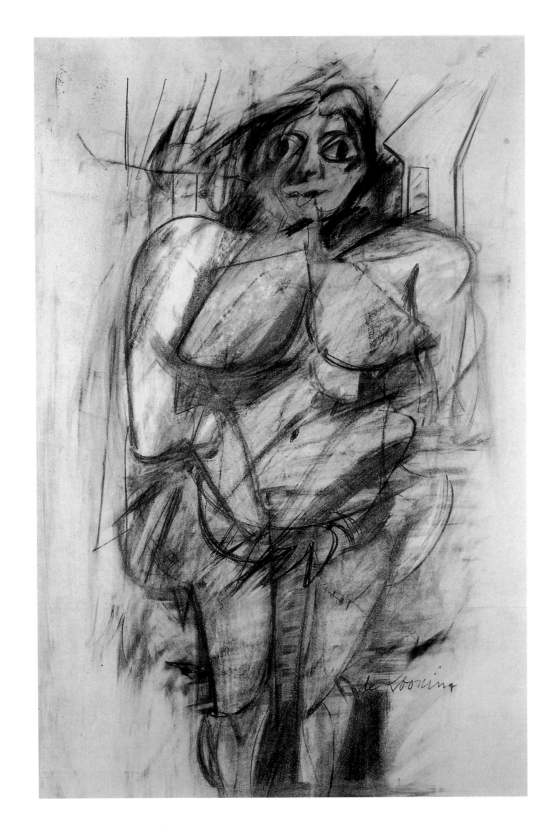

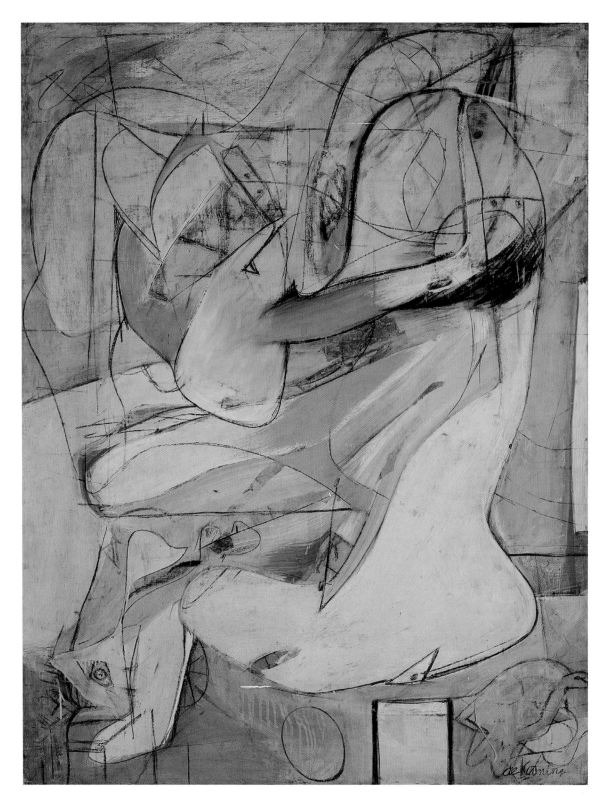

From Rotterdam to New York

Nothing in his childhood suggested that Willem de Kooning, born in Rotterdam, Holland, in 1904, would one day be a world-famous painter. His family life was difficult. His parents – his father was a successful wholesale beverage distributor – divorced when Willem was four. A struggle ensued over the custody of their son, which eventually was granted to his mother.

Early on Willem showed an extraordinary talent for drawing, so he was apprenticed, at the age of twelve, to the interior decorators Jan and Jaap Gidding in Rotterdam. De Kooning's mentors likewise soon recognized his unusual talent, and enrolled him in evening drawing classes at the Academy of Art and Technology. Here the young de Kooning received a thorough grounding in art theory and practice. The classes he took covered perspective, proportion, life drawing and the imitation of wood grain and marbling. Theoretical instruction included European and non-European art history, from ancient times to the Renaissance.

In 1920 de Kooning became an assistant to Bernard Romein, art director at a large Rotterdam department store. Romein introduced him to the work of the Dutch modernist Piet Mondrian and the De Stijl group. De Kooning began to paint, although he apparently viewed the medium with a certain detachment, as he would note in retrospect in 1960, "When we went to the academy [in Rotterdam, in the early 1920s] – doing painting, decorating, making a living – young artists were not interested in painting per se." Painting, in de Kooning's eyes, was something "for men with beards," that is, nineteenth-century greats, such as Paul Cézanne and Claude Monet. The idea of equipping himself with a palette and painting pictures seemed ridiculous and quite un-modern to him.

On the other hand, he was plagued by a feeling of not really understanding the true nature of the painting medium. Yet he continued his courses at the academy. As early as 1924 de Kooning's craft skills had developed to the point that he was able to finance a several months' study trip through Belgium by painting signs and portraits. After returning to Rotterdam, he reenrolled in the academy in 1925.

During that period de Kooning pictured his future in the field of applied or commercial art. A career in decorative painting or design were the options he considered. His later decision to emigrate to the United States would be strongly

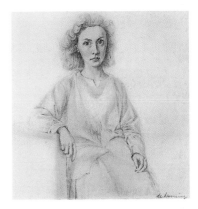

Portrait of Elaine, ca. 1940–41
Pencil on paper, 31.2 x 20.3 cm
Private collection

"Once he said he'd like to paint like Ingres and Soutine – both at the same time. He made a few exquisite, Ingres-like drawings (one, a portrait of Elaine), but then he said that if he kept this up he'd go crazy."
RUDOLPH BURCKHARDT, 1989

ILLUSTRATION PAGE 10:
Pink Angels, 1945
Oil and charcoal on canvas, 132.1 x 101.6 cm
Los Angeles, CA, Frederick R. Weisman Art Foundation

influenced by this goal. As de Kooning would say years later, painters flocked to Paris, while "a modern person" was attracted to America.

Despite envisioning a career in commercial art, de Kooning became deeply involved in painting. The ideas of the European avant-garde, foremost those of Vassily Kandinsky, Paul Klee, Henri Matisse and Pablo Picasso, would become an essential foundation for his own development. Picasso especially developed into a key source of inspiration for de Kooning's early work. A good example is *Man* (p. 16), a figurative study in pink and gray reminiscent of an early phase in Picasso's art. Analytic Cubism likewise fascinated de Kooning. This gave rise to such compositions as the unfinished *Portrait of Rudolph Burckhardt* (p. 17) and *Seated Woman* (p. 19). In the garishly colored *Pink Lady* (p. 18), the distorted, averted face even seems directly borrowed from the despairing faces in Picasso's renowned antiwar painting *Guernica*.

Yet artists from earlier periods played a part in de Kooning's early development as well. As he would later tell Harold Rosenberg in the early 1970s, "I am an eclectic painter by chance; I can open almost any book of reproductions and find a painting I could be influenced by." The often close relationship between his paintings and drawings is striking: the techniques developed in the drawings find a direct echo in his paintings. Still, he hardly ever made preliminary drawings in the true sense until the groundbreaking *Women* series of the 1950s. De Kooning drew "on the side," using this technique as a "means to think."

By 1926 the Great Depression was looming on the horizon. De Kooning, just twenty-two, decided to emigrate to the United States. In the dynamic New World, he hoped he would have a better chance of earning a living than in constricted Holland. According to later statements, he knew nothing about American artists at that point: "I didn't expect that there were any artists here. We never heard in Holland that there were artists in America." Art was traditionally at home in Europe – a widespread view at the time. America meant economic prosperity and faith in the American Dream, that anybody can make good as

Still Life (Bowl, Pitcher and Jug), ca. 1921
Conte crayon and charcoal on paper,
47 x 61.6 cm
New York, The Metropolitan Museum of Art.
Van Day Truex Fund, 1983 (1983.436)

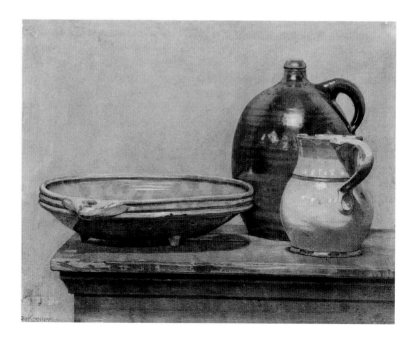

Reclining Nude (Juliet Brauner), ca. 1938
Pencil on paper, 26 x 32.4 cm
Private collection

long as he or she works hard enough. De Kooning earned his passage as a manual laborer in the engine room of the ship that took him to the United States, which he entered without papers. Soon after his arrival he found a job as a house painter in Hoboken, New Jersey. He spoke very little English, and later joked in an interview that the only word he knew back then was "yes." His initial salary was opulent, as far as he was concerned – nine dollars a day. After five months on the job he decided to try his hand at commercial art.

A portfolio of work samples was rapidly assembled, and de Kooning immediately found a position. He began working without even inquiring into the amount of his salary, " … because I thought if I made twelve dollars a day as a house painter, I would make at least twenty dollars a day being an artist. Then at the end of two weeks, the man gave me twenty-five dollars and I was so astonished I asked him if that was a day's pay. He said, 'No, that's for a whole week.' And I immediately quit and went back to house painting."

America held other surprises in store for him as well. In Greenwich Village, New York, de Kooning discovered a tradition of American painting and poetry that he had no idea existed. He also came in contact with the work of European artists. New York shows of Paul Klee and Henri Matisse profoundly impressed him. As the 1920s came to an end de Kooning began increasingly to divorce himself from earlier ideals and paint more frequently. At first he was unable to live off the proceeds from his art and had to continue his sign painting and display window decoration. In the compositions of this period the paint application was thin, and de Kooning often used ordinary tempera. It was not until later, when he was able to afford more and higher-quality paints, that he would begin to employ them lavishly. Nevertheless, from the very beginning de Kooning was self-confident enough to consider himself an artist. As he would later say of the obstacles he faced back then, "So I styled myself as an artist and it was very difficult. But it was a much better state of mind." By the early 1930s he had

Study for World's Fair Mural Medicine, 1937
Pencil, 18.4 x 22.8 cm
New York, the Estate of Rudy Burckhardt

already built up a circle of friends – writers, poets, musicians and artists. A few of them regularly bought pictures from him, if at the modest prices one tends to grant friends.

A meeting with Arshile Gorky, whom de Kooning got to know by chance in 1930, marked the first decisive turn in his artistic career. The differences between the two painters were striking. De Kooning had enjoyed a well-founded academic training in a large European city. Gorky, who was born in Armenia and emigrated to America at age fifteen, had had no training at all. Yet he possessed a natural sense of art, as de Kooning would later admiringly admit: "And for some mysterious reason, he knew lots more about painting and art – he just knew it by nature – things I was supposed to know and feel and understand – he really did it better. He had an extraordinary gift for hitting the nail on the head – very remarkable." Gorky's paintings, strongly influenced by French avant-garde currents, made their mark on the New York scene. His work was like a filter, a lens through which French models were enlarged, altered, refracted and made assimilable. Above all Gorky acted as a pioneer of a modern style. He took an open stance against the Marxist currents of the period and their cry for a socialist realism, an art Gorky once described as "poor art for poor people."

De Kooning sought Gorky's company, and soon a deep friendship developed between the two. They used to meet at de Kooning's studio on Forty-Second Street and debate about art. They went to galleries and museums together, especially to the Museum of Modern Art, which had opened the year before, in 1929. Their interest in the art of the distant and more recent past was eclectic, but in quite different ways. Gorky analyzed pictures, especially of European modernism, by painting "his own version" of them. De Kooning took certain elements from them and incorporated these into his own work in such a way that the sources were less clearly recognizable in the final result. As he would explain to the American art critic Harold Rosenberg in 1972, it was "like the smile of the Cheshire Cat in *Alice*: the smile left over when the cat is gone." In an open letter to the journal *ARTnews,* written in 1949, a year after Gorky's suicide, de Kooning would definitely reject the opinion that Gorky had also been influenced by him: "I am glad that it is about impossible to get away from his powerful influence. As long as I keep it with myself, I'll be doing alright. Sweet Arshile, bless your dear heart."

In 1934 de Kooning launched into his first abstract compositions. Later he would destroy most of them, usually by painting them over. Only those that conformed with his stringent notions of a new masterpiece would escape de

"I was lucky when I came to this country to meet the three smartest guys on the scene: Gorky, Stuart Davis and John Graham. They knew I had my own eyes, but I wasn't always looking in the right direction. I was certainly in need of a helping hand at times. Now I feel like Manet who said, 'Yes, I am influenced by everybody. But every time I put my hands in my pockets, I find someone else's fingers there.'"
WILLEM DE KOONING, 1972

14

Kooning's merciless self-criticism. He was continually plagued by self-doubt. Should he put all his money on a single card and devote himself entirely to art? At first he was unable to find an answer to this question, went on searching for models to emulate, for fellow-painters with whom he could exchange ideas. In the process, at a 1929 exhibition opening in the Dudensing Gallery in New York, de Kooning met John Graham, a Russian exile who during frequent trips to Paris had immersed himself in the work of artists like André Breton, Paul Eluard and Pablo Picasso, and who was an ardent champion of modernism. Graham would become an important stimulus and supporter for de Kooning. His 1937 book, *System and Dialectics of Art*, a compendium of art theories and cultural history, was one of the few books of the period to be found in the studios of all those artists who would make their name in the 1940s. In 1942 Graham would mount a group show, "American and French Paintings," at the McMillen Gallery. This key show included works by de Kooning and other American artists, alongside those of established Europeans such as Georges Braque, Picasso and Georges Rouault. It also led to the first meeting of de Kooning, who described Graham as his "discoverer," and Jackson Pollock.

The daily struggle to make ends meet continued to determine artists' lives.

Pablo Picasso
Two Brothers, 1906
Oil on canvas, 142 x 97 cm
Basel, Öffentliche Kunstsammlung, Kunstmuseum Basel

In his male portraits of the 1930s and 1940s, de Kooning oriented himself to works by other artists, including those of Picasso's Pink Period of 1905–06. Picasso derived his motifs from observations of circus performers and things he saw in the artists' quarter of Montmartre in Paris or during travels through Holland and Spain.

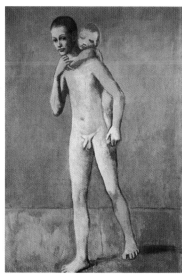

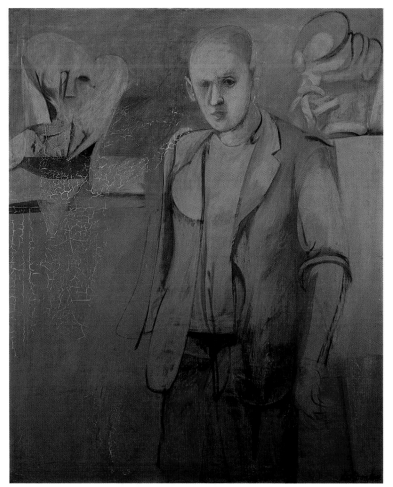

Standing Man, ca. 1942
Oil on canvas, 104.5 x 86.7 cm
Hartford, CT, Wadsworth Atheneum Museum of Art. The Ella Gallup Sumner and Mary Catlin Sumner Collection Fund

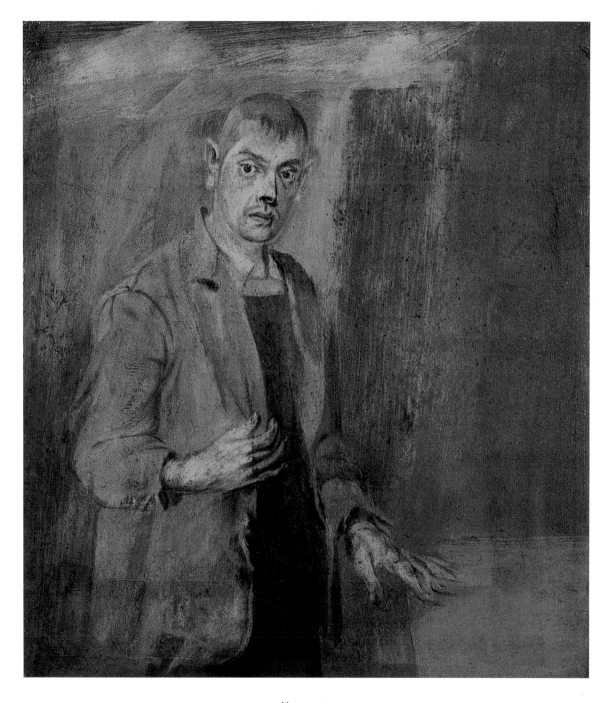

Man, ca. 1939
Oil on paper, mounted on composition board, 28.6 x 24.8 cm
Private collection

"Then, when the Depression came, I got on the WPA, and I met all kinds of other painters and sculptors and writers and poets and architects, all in the same boat, because America never really cared much for people who do those things. I was on the Project about a year or a year and a half, and that really made it stick, this attitude, because the amount of money we made on the Project was rather fair; in the Depression days one could live modestly and nicely. So I felt, well, I have to just keep doing that. The decision to take was: was it worth it to put all my eggs in one basket, that kind of basket of art. I didn't know if I really was competent enough, if I felt it enough."

WILLEM DE KOONING, 1963

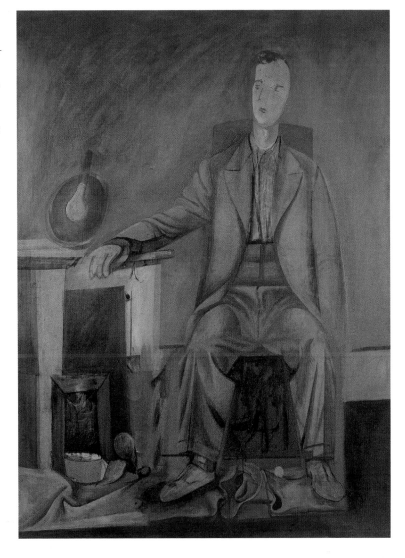

Portrait of Rudolph Burckhardt, ca. 1939
Oil on canvas, 121.9 x 91.4 cm
New York, the Estate of Rudy Burckhardt

ILLUSTRATION PAGE 18:
Pink Lady, ca. 1944
Oil and charcoal on composition board,
123 x 90.6 cm
Private collection

ILLUSTRATION PAGE 19:
Seated Woman, ca. 1940
Oil and charcoal on Masonite, 137.3 x 91.4 cm
Philadelphia, PA, Philadelphia Museum of Art.
The Albert M. Greenfield and Elizabeth M.
Greenfield Collection

The Great Depression of the 1930s hit them especially hard. In 1935 de Kooning was accepted into the Federal Art Project, under the Works Progress Administration (WPA). The project, called into being by President Franklin D. Roosevelt, was designed to supply commissions to artists who were suffering under the Depression. Over 2,500 murals, 18,000 sculptures and hundreds of thousands of prints, paintings and photographs would be done throughout America under the aegis of the WPA. For over a year de Kooning worked on a decoration project for a shipping company, the "French Line Pier Project," in collaboration with French artist Fernand Léger, whose work he greatly admired. For the first time de Kooning was able to devote himself entirely to his art, a decisive experience for him. As he would later recall in an interview with Irving Sandler in 1959, it "gave me such a terrific feeling that I gave up painting on the side and took a different attitude. After the Project I decided to paint and do odd jobs on the side."

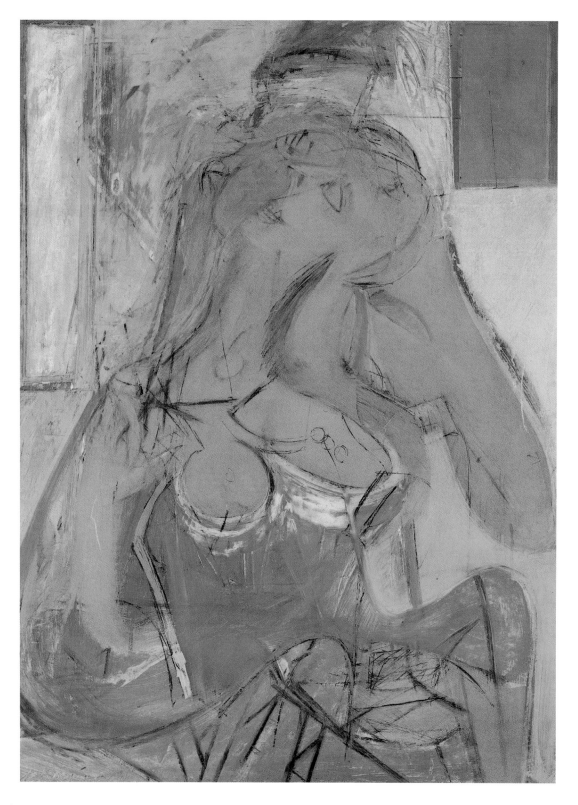

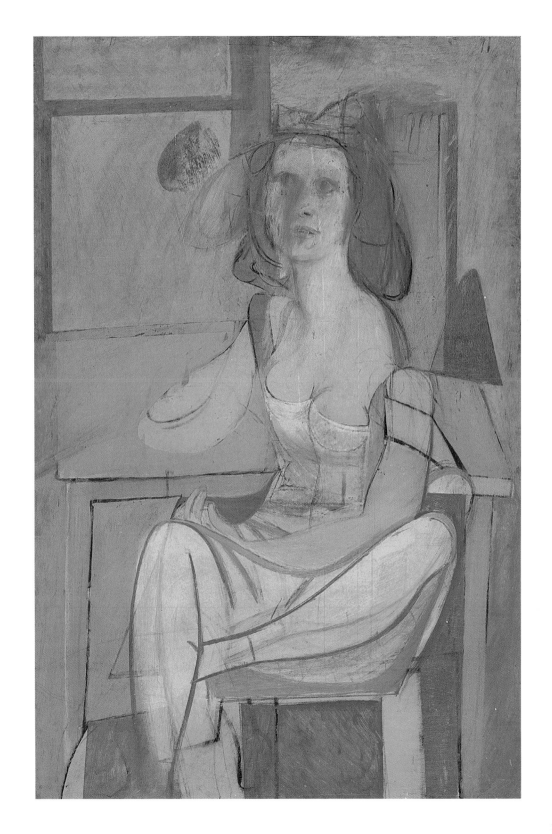

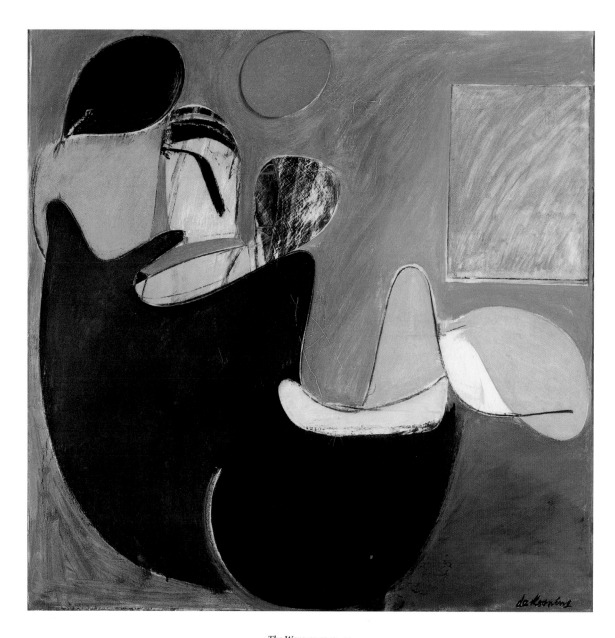

The Wave, ca. 1942–44
Oil on fiberboard, 121.9 x 121.9 cm
Washington, DC, Smithsonian American Art Museum

Initially, however, none of de Kooning's designs was actually executed. His conception for various walls in the Williamsburg Federal Housing Project, Brooklyn, seemingly inspired by Joan Miró, found as little echo as a sketch that was shown in 1936 in an exhibition at the Museum of Modern Art. De Kooning's paintings of the period reflected the hopeless situation of many people during the Great Depression: melancholy figures in shades of gray and pink, workers in shabby clothes, anxious faces. At first it was mainly friends who supported him and his art. In 1936 de Kooning befriended two of his neighbors, the author and dance critic Edwin Denby and the photographer Rudolph Burckhardt, who became his first collectors. Especially Burckhardt, a descendant of the renowned cultural historian Jacob Burckhardt, not only collected de Kooning's art but, with his carefully composed black and white photographs, shaped the public image of the Abstract Expressionist generation.

In 1936 de Kooning came in contact with members of the fledgling association of American Abstract Artists (AAA). His political savvy assured him of rapid acceptance into the group, which was dominated by communist ideas. Yet

Elegy, 1939
Oil and charcoal on board, 102.2 x 121.6 cm
Private collection

The organic shapes and black contours in *Elegy* recall paintings by Joan Miró, but also works by de Kooning's friend Arshile Gorky. The picture was shown in the exhibition "Twentieth Century Paintings," held in 1943 at the Bignou Gallery, New York, where it was acquired by the colletor Helena Rubenstein.

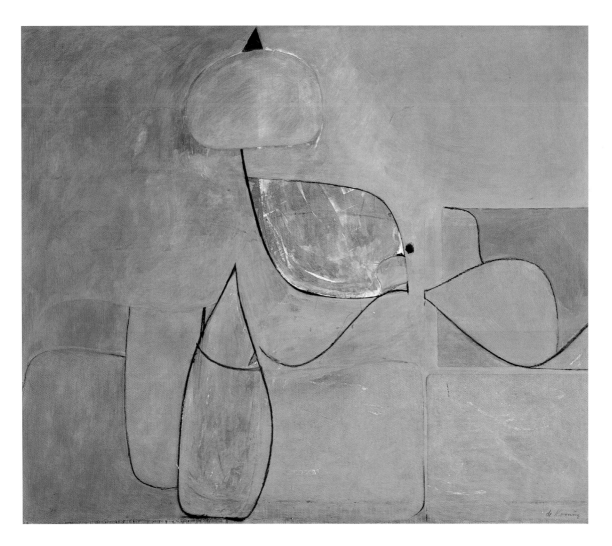

**Abstraction, or Study for Marsh Series,
or Study for Pink Angels**, 1945
Pastel and pencil on paper, 30.5 x 35.3 cm
Private collection

In his sketch for *Pink Angels* de Kooning employed organic forms that recall flattened, fragmented and collaged figures and reflect his reaction to European Surrealist art. The New York School of the 1940s was materially influenced by members of the Surrealist movement, such as Max Ernst and Yves Tanguy, who had fled Nazi persecution and emigrated to the U.S.

de Kooning insisted on his independence. Despite several inquiries, he declined to become an official member of the A A A. As he would later recall, he could not accept the limitations the group imposed, its attempts to prevent him from doing certain things – the very things he was interested in trying. Ultimately, de Kooning said, he remained a foreigner, different, because he was interested in art as a whole. Among the "forbidden things" was figuration, which de Kooning continued to employ and which remained present even in biomorphic, abstract compositions like *The Wave* (p. 20) and *Abstraction, or Study for Marsh Series, or Study for Pink Angels* (p. 22).

The year 1937 finally brought a first public success – a mural commission for the Hall of Pharmacy at the 1939 New York World's Fair. De Kooning's design was accepted, and later translated into a full-size painting by professional muralists. Yet this success was short-lived: de Kooning's name was struck from the W P A lists. Congress had passed a bill that permitted only American artists to participate in the Federal Art Project, and de Kooning had yet to become an American

Still Life, 1945
Chalk and charcoal on paper, 33.7 x 44.6 cm
Los Angeles, CA, Frederick R. Weisman Art
Foundation

citizen. Despite such setbacks his development made great strides. As his design
for the Hall of Pharmacy mural clearly shows, de Kooning, like Gorky, avoided
making a hard-and-fast decision between an abstract and an objective approach.
The portraits he made of his later wife, artist and critic Elaine Fried, have the
look of precise studies. On the other hand pencil drawings like *Reclining Nude*
(p. 13) reflect de Kooning's attempts to translate organic forms into abstract
terms without entirely dispensing with the former. Contemporaries like the in-
fluential critic Clement Greenberg found these pictures original and new. Strik-
ingly even de Kooning's later abstract compositions, such as *Pink Angels* (p. 10),
continued to be determined by the figure. As Thomas Hess would note in 1959,
"Like Siamese twins, his abstract pictures live off the figures; the figures canni-
balize the abstractions."

Towards the end of the 1930s de Kooning met Franz Kline and Barnett New-
man, two other artists who provided new impulses for his own work. In 1937
he moved to a new loft, on Twenty-Second Street. Here a continuing involve-
ment with the art of Picasso and Gorky led to a series of self-portraits, done in
1938 and thereafter.

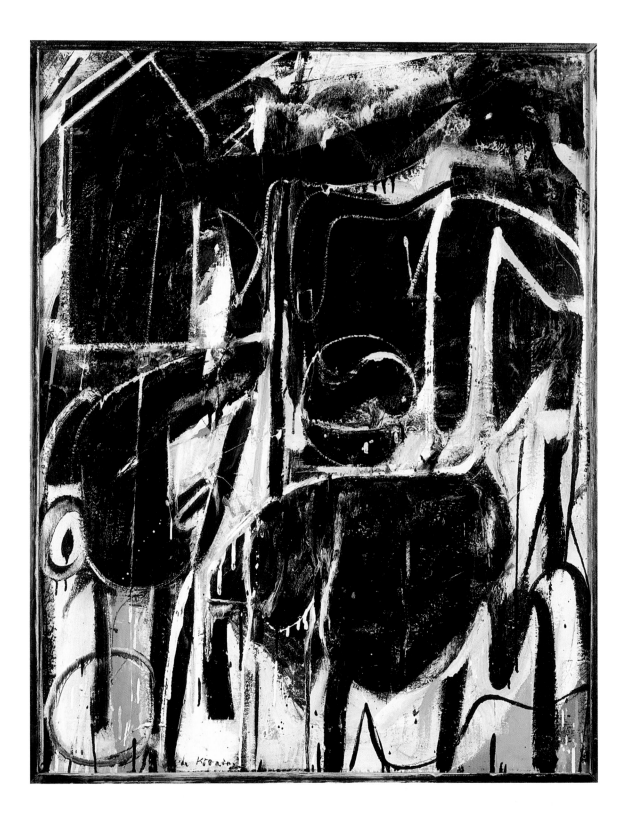

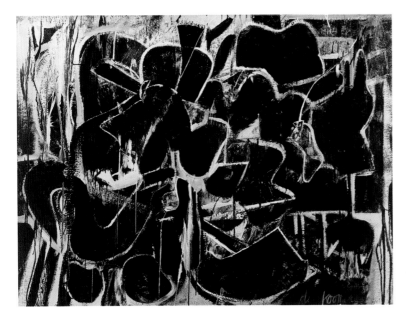

Painting, 1948
Enamel and oil on canvas, 108.4 x 142.6 cm
New York, The Museum of Modern Art.
Purchase

De Kooning began to participate with increasing frequency in exhibitions. In 1943 he was represented in "Twentieth Century Paintings," at the Bignou Gallery in New York, followed the next year by "Abstract and Surrealist Art in America," at the Sidney Janis Gallery, also in New York. In 1945 de Kooning was included, alongside Gorky and other American artists, in "A Painting Prophecy: 1950," shown at the David Porter Gallery in Washington, D.C. Each exhibition represented a further step in his career. Yet despite the prestige of these first showings de Kooning's financial situation remained precarious.

Nevertheless, the presence of de Kooning's work in exhibitions attracted the attention of influential critics and museums. Between 1947 and 1950 emerged large-format, abstract compositions in black and white, such as *Orestes, Painting* (p. 25) and *Black Friday* (p. 24). Their limited color range was, at least in part, a result of a lack of funds, the black paint having been available at a low price. De Kooning made an impressive virtue of necessity, and the critics Clement Greenberg and Harold Rosenberg took note. At this period both were working out their theories of Abstract Expressionism, and these were perfectly applicable to the artist's large-scale abstractions in enamel and oil on canvas. De Kooning's unique style soon made him a leading figure in the new American painting – and this despite the fact that he neither belonged to the first echelon of artists represented by Peggy Guggenheim in her gallery Art of This Century, nor did he attend the publicity-promoting Uptown parties that were then a feature of the scene. Yet he was a brilliant conversationalist with strong personal views, which he was capable of communicating eloquently. Only when talk turned to the art business, and power interests that ran counter to his convictions came into play, could de Kooning become intransigent. In 1942 he even refused to exhibit alongside Jackson Pollock in a show organized by Peggy Guggenheim, thinking Pollock, like most of the artists represented, was too strongly influenced by Surrealism. It was not until the John Graham show two years later, organized by dealer Sidney Janis under the title "Abstract and Surrealist Art in America," that de Kooning would agree to show alongside Pollock.

"Bill had his first one-man show at the Egan Gallery in April of 1948, the month I began writing reviews for *ARTnews*. Nothing sold from Bill's show, and my reviews brought in only two dollars apiece. We were looking forward to the summer with trepidation. We were penniless with no prospects."
ELAINE DE KOONING, 1983

ILLUSTRATION PAGE 24:
Black Friday, 1948
Enamel and oil on pressed wood panel,
125 x 99 cm
Princeton, NJ, Princeton University Art
Museum. Gift of H. Gates Lloyd, Class of 1923,
and Mrs. Lloyd in honor of the Class of 1923

His outward self-confidence and uncompromising attitude seemed very attractive at the end of the 1940s. De Kooning rapidly gained a circle of admirers, abetted by his teaching activities in 1948 and 1950 at Black Mountain College, North Carolina, and the Yale School of Art and Architecture, New Haven, Connecticut. Black Mountain College long figured as a talent factory for the young American avant-garde. Jackson Pollock and Robert Rauschenberg took courses or taught there. The school was marked by an extremely productive tension, between rigorous analytic abstraction – personified by college president Josef Albers, who represented the lucidity of the Dessau Bauhaus – and the influence of Far Eastern philosophy, conveyed especially by the composer John Cage.

By the end of the 1940s, de Kooning had advanced to become a respected artist. In October 1948 the Museum of Modern Art showed a large-format black and white canvas, *Painting* (p. 25), acquired from his first solo exhibition, at the Charles Egan Gallery in New York. Yet de Kooning still wrestled with his compositions, oscillating between abstraction and figuration. A case in point is *Excavation* (p. 27), an unusually large canvas, measuring two by two-and-one-

Asheville, 1948
Oil and enamel on cardboard, 64.9 x 80.7 cm
Washington, DC, The Phillips Collection

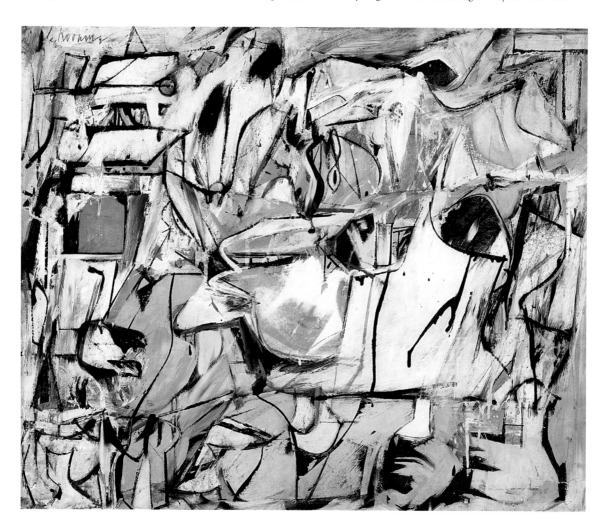

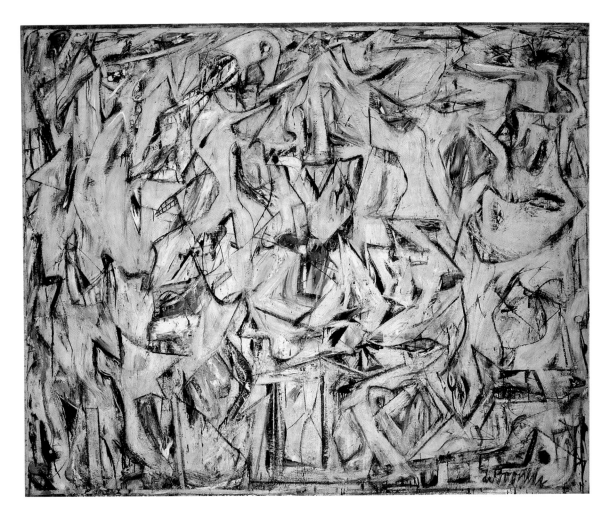

half meters. The lines in the painting call to mind the contours of grotesque, distorted figures which have been laboriously excavated from the picture surface, like graffiti on some big-city wall. De Kooning finished the painting just in time to participate in the twenty-fifth Venice Biennale in 1950. That same year saw him give his approach a new turn, when he began work on *Woman I* (p. 6).

Excavation, 1950
Oil on canvas, 206.2 x 257.3 cm
Chicago, IL, The Art Institute of Chicago.
Mr. and Mrs. Frank G. Logan Purchase Prize.
Gift of Mr. and Mrs. Noah Goldowsky and
Edgar Kaufmann, Jr., 1952.1

"Style is a fraud. I always felt that the Greeks were hiding behind their columns. It was a horrible idea of van Doesburg and Mondrian to try to force a style. The reactionary strength of power is that it keeps style and things going."
WILLEM DE KOONING, 1949

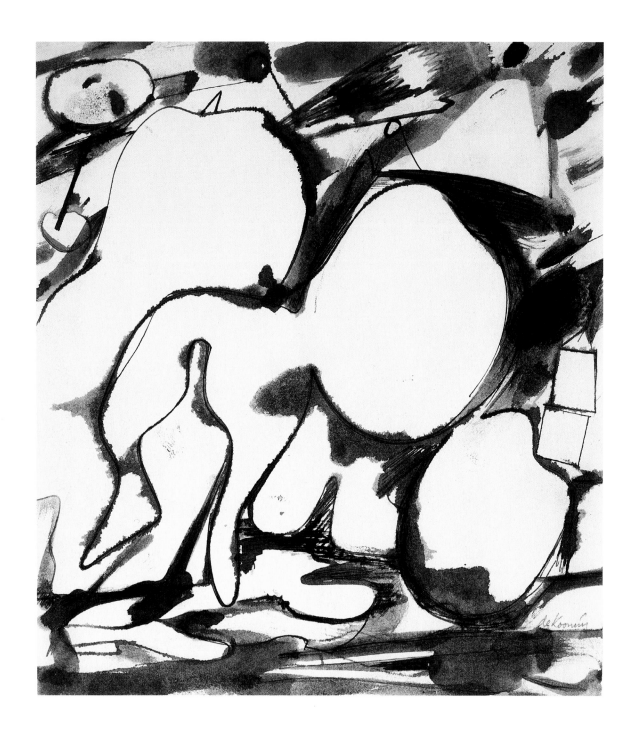

***Untitled**, 1948*
Pen and ink and ink wash on paper, 23.7 x 21.4 cm
Washington, DC, Hirshhorn Museum and Sculpture Garden,
Smithsonian Institution. Gift of Joseph H. Hirshhorn, 1966

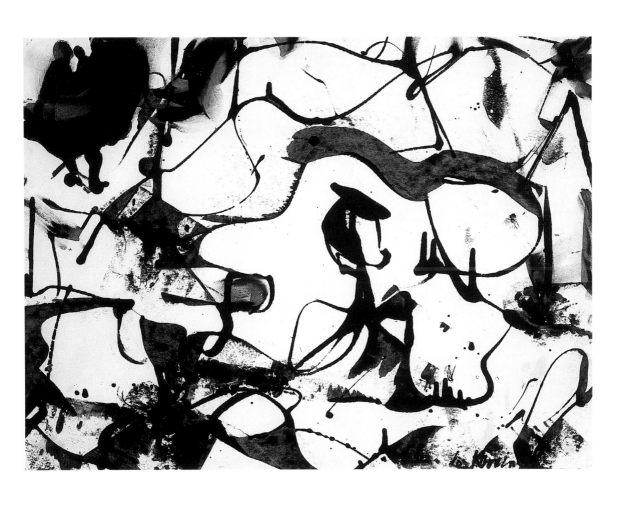

Untitled, ca. 1949–50
Enamel on paper, 48 x 64.9 cm
Washington, DC, Hirshhorn Museum and Sculpture Garden,
Smithsonian Institution. Gift of Joseph H. Hirshhorn, 1966

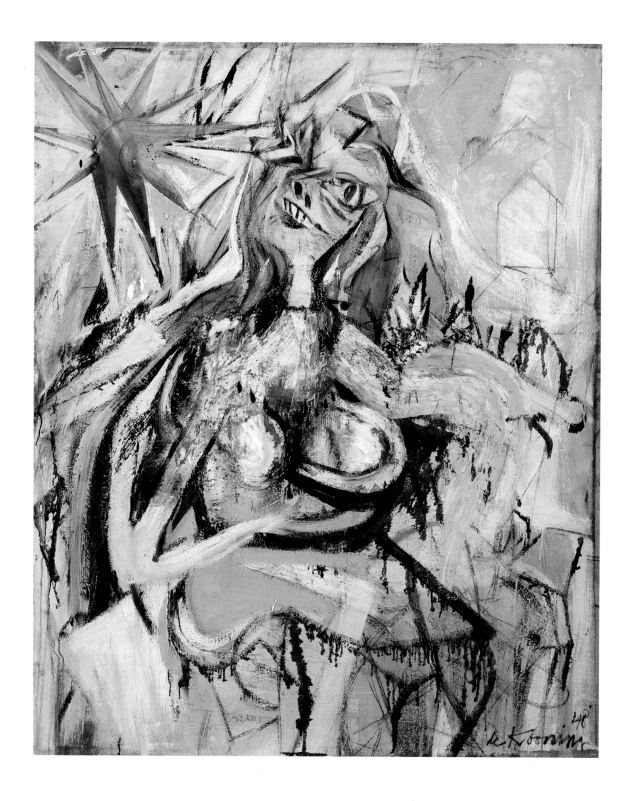

De Kooning's *Women*: Scandal and Success

The year 1953 witnessed a breakthrough for de Kooning, during which he received wide public recognition thanks to a controversial exhibition of his *Women* series at Sidney Janis's influential New York gallery. Looking back from the vantage point of the 1990s, the American art critic Peter Schjeldahl inquired into the conditions under which these paintings were done in the early 1950s. In addition to possible psychological and formal motives, Schjeldahl recalled that changes were then taking place on the New York art scene that may have provided the background for de Kooning's deliberately provocative images of women. "Now consider that you are de Kooning," Schjeldahl wrote in 1992, "with a well-established Downtown reputation as a painter's painter. Among other things, you draw like an angel. But just as you start to win the game, the rules change. With critic Clement Greenberg improvising theory for it, a brand of de-composed abstraction evolves and is promoted as the living end. It is tailored perfectly for Jackson Pollock, Barnett Newman, and others who can't draw worth much. You are threatened with being old-hat before you have gotten to be new-hat. At your easel, you commence to throw a pointed and expedient tantrum." As the abstract, subjective gestural painting of a Pollock began to dominate the scene, de Kooning faced the next step in his development, which – after abstract compositions like *Excavation* (p. 27) – would lead to a combination of abstraction and figuration.

De Kooning had always had scruples about his work, even that of the early phase, at the beginning of the 1930s. Edwin Denby, who wrote copiously about dance, once recalled that during that period de Kooning could easily finish a painting within two days. Then he would step back, scrutinize it "like a choreographer one of his adepts" and condemn it as "easy" or "facile." The self-critical painter's working process has often been described as a "heroic battle," an incessant struggle and a continual starting again from scratch. This soon earned him the reputation of being unable to finish his paintings. "De Kooning can make a big painting in a day, scrape it off in a few minutes, paint it again the next day – a painting a day for a year on the same canvas," Thomas Hess summed up in 1959. Prior to 1954 the artist sold his paintings only very sporadically, and kept old canvases in his studio for long periods of time. As he reworked them, he often built up a thick layer of impasto, passages of which were later scraped off to reveal earlier, underlying elements that shimmered like ghostly apparitions …

Willem and Elaine de Kooning, 1953
Photograph by Hans Namuth

ILLUSTRATION PAGE 30:
Woman, 1948
Oil and enamel on fiberboard, 136.3 x 113.5 cm
Washington, DC, Hirshhorn Museum and Sculpture Garden, Smithsonian Institution. Gift of the Joseph H. Hirshhorn Foundation, 1966

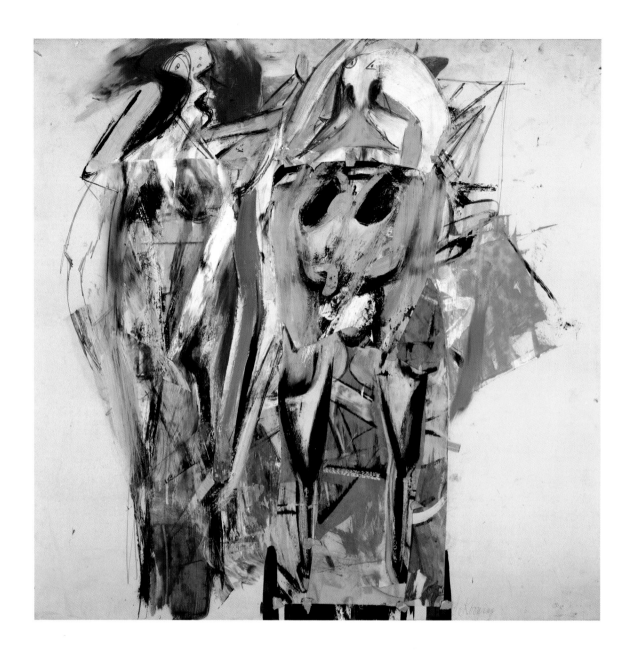

Two Women on a Wharf, 1949
Oil, enamel, pencil and collage on paper,
62.1 x 62.4 cm
Toronto, Art Gallery of Ontario

Later this procedure would extend, as in *Easter Monday* (p. 45) or *Gotham News* (p. 44), to the incorporation of newspaper transfers into the compositions. Since he sometimes let his canvases stand for days at a time, de Kooning would cover the wet paint with newspaper in order to delay the drying process. When the paper was removed, ad illustrations, headlines and copy had frequently been transferred to the oil paint. De Kooning embraced this effect, allowing such collage elements produced by controlled chance to play a role in the composition, as if in allusion to Cubist paintings. The long and laborious emergence of his compositions, as Thomas Hess wrote, was like "a bet kept riding on rolls of the dice."

Prior to the *Women* series de Kooning had produced, in 1938–45 and 1947–49, large groups of depictions of female figures, which often clearly reflected the style of artists he admired. *Woman*, 1948 (p. 30), for instance, was obviously modeled on works by Picasso. The pictures of this period show grimacing faces with bared teeth, occasionally combined with gestures of female seduction, such as the head leaning back in *Pink Lady* (p. 18). In an interview with David Sylvester in 1960 de Kooning explained, "The *Women* had to do with the female painted through all the ages, all those idols, and maybe I was stuck to a certain extent; I couldn't go on."

Still, this motif – and de Kooning's frequently harsh treatment of it – was often viewed as a personal obsession, a view to which his own statements contributed. "The *Women* became compulsive," he reported, "in the sense of not being able to get hold of it – it really is very funny to get stuck with a woman's knee for instance. You say, 'What the hell am I going to do with that now?'; it's really ridiculous. It may be that it fascinates me, that it isn't supposed to be done."

In the struggle with the fundamentals of painting that his years of work on the *Women* series entailed, de Kooning also reflected on the prevailing female image of the day. As early as 1951 – ten years before Andy Warhol would interpret the motif – he devoted a drawing to the Hollywood icon Marilyn Monroe (p. 33). And as the various stages in the over two-year process of finishing *Woman I* indicated, de Kooning concerned himself with the surfaces on which the female image appeared daily. This is seen in the perfect dazzling smile of the advertisements and star photos he cut out of magazines, as from a cigarette ad. As the documentary photographs of the six states of *Woman I* (p. 34) indicate, de Kooning returned to the face time and again. It was really not the knee on which he got "stuck," as he had told David Sylvester. This element remained unchanged through almost every state. What preoccupied de Kooning most was the woman's facial expression, gaze, smile. The female figure on canvas, especially her face, seemed to resist the painterly process of abstraction.

Many critics viewed the series of six *Women* and the accompanying drawings as archetypal "metaphors for his own and modern man's existential condition," as Irving Sandler wrote. According to a 1953 review by James Fitzsimmons in *Art* de Kooning was involved "in a terrible struggle with a female force … a bloody hand to hand combat" with a "female personification of all that is unacceptable, perverse and infantile in ourselves." De Kooning himself tended to resist such psychological interpretations, as when he explained to David Sylvester in 1960 that "certain artists and critics attacked me for painting the *Women*, but I felt that this was their problem, not mine. I don't really feel like a non-objective painter at all. Today, some artists feel they have to go back to the figure, and that word 'figure' becomes such a ridiculous omen – if you pick up some paint with your brush and make somebody's nose with it, this is rather ridiculous when you think of it, theoretically or philosophically. It's really absurd to make an image, like a human image, with paint, today, when you think about it, since we have this problem of doing it or not doing it. But then all of a sudden it was even more absurd not to do it."

At the same time de Kooning addressed the issue of the contemporary meaning of beauty. As Barnett Newman described the late 1940s and the 1950s in a 1962 interview, "People were painting a beautiful world, and at that time we realized that the world wasn't beautiful. The question, the moral question, that each of us examined – de Kooning, Pollock, myself – was: what was there to beautify?"

Study for "Marilyn Monroe", 1951
Pastel and pencil on paper, 42.5 x 24.7 cm
Carbondale, CO, Collection of John and
Kimiko Powers

"I cut out a lot of mouths. First of all, I thought everything ought to have a mouth. Maybe it was like a pun. Maybe it's sexual. But whatever it is, I used to cut out a lot of mouths and then I painted those figures and then I put the mouth more or less in the place where it was supposed to be. It always turned out to be very beautiful and it helped me immensely to have this real thing."
WILLEM DE KOONING, 1960

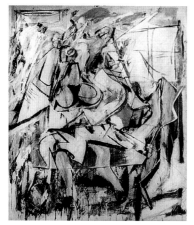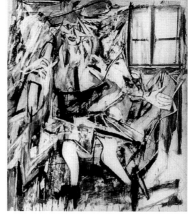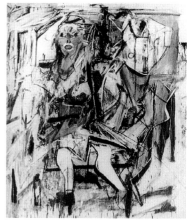

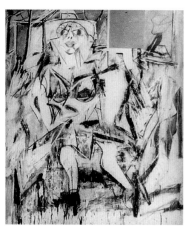

Six Stages of "Woman I", 1950–52
Documentary photo series on the development
of de Kooning's *Woman I*
New York, the Estate of Rudy Burckhardt

"One day de Kooning explained to Harold
Rosenberg: 'Janis wants me to paint some ab-
stractions and says he can sell any number of
black and whites, but he can't move the *Women*.
I need the money. So if I were an *honest* man,
I'd paint abstractions. But I have no integrity.
So I keep painting the *Women*.'"
THOMAS B. HESS, 1968

Perhaps de Kooning reacted to this question by pursuing the violent, subcon-
scious, instinctual aspects of the motif of *Women. Monumental Woman* (p. 41),
for instance, recalls the depictions of female murder victims by such predeces-
sors as George Grosz and contemporaries like Francis Bacon, who in the process
of painting virtually dissected the human body.

The *Women* series and the debate it triggered would make de Kooning inter-
nationally known within the space of a few years. In 1959, three years after the
death of de Kooning's rival, Jackson Pollock, in an automobile accident, Thomas
Hess could even state that "By the mid-1950's he had become the most influential
artist at work in the world." Hess, with other critics, such as Clement Greenberg
and Harold Rosenberg, materially contributed to de Kooning's success, for they
often wrote their reviews in close collaboration with artists who were also their
personal friends, as Elaine de Kooning's portraits of Rosenberg and Hess attest
(p. 42).

If this "public relations campaign" was conducted for the Abstract Expres-
sionists in general, it was pursued with particular intensity in the case of de
Kooning's *Women*. Hess, then editor of *ARTnews*, documented the emergence
of *Woman I* for a series of articles devoted to the creative process of contempo-
rary artists. In addition the publication date was chosen to coincide with the
presentation of the *Women* canvases at the Sidney Janis Gallery. The text was

illustrated with photographs, taken by Rudolph Burckhardt in 1950–52, that not only recorded the development of *Woman I* (p. 6), but infused the process with dramatic intensity. The photos served not least to underscore the artist's drawing skills, mentioned at the outset. In contrast to his usual practice of developing the image directly on the canvas, this time de Kooning made numerous preparatory sketches on paper and pasted them onto the canvas as an aid to working out certain elements. He planned, composed and rejected. In fact he was ready to write off *Woman I* as a complete failure and had removed the canvas from the stretchers when the American art historian Meyer Schapiro visited him in the studio in March 1952 and encouraged him to rework the image once again and finish it. After the 1953 Janis show, *Woman I* was acquired before the year was out by the Museum of Modern Art.

On his road to success, de Kooning enjoyed the support not only of male critics like Hess and Rosenberg but of a female one as well. In 1943 he had married the art student Elaine Fried, and five years later Elaine de Kooning had begun to publish regularly in *ARTnews*. A committed critic and fellow artist, she furthered her husband's reputation and helped shape the couple's public image. A photograph taken by Hans Namuth in 1953 shows Elaine and Willem de Kooning at the

ILLUSTRATION PAGE 36:
Woman II, 1952
Oil on canvas, 149.9 x 109.3 cm
New York, The Museum of Modern Art.
Gift of Mrs. John D. Rockefeller 3rd

ILLUSTRATION PAGE 37:
Woman III, 1952–53
Oil on canvas, 172.7 x 123.2 cm
Los Angeles, CA, Collection of David Geffen

Torsos, Two Women, ca. 1952–53
Pastel on paper, 47.3 x 61 cm
Chicago, IL, The Art Institute of Chicago.
Joseph H. Wrenn Memorial Collection, 1955.637

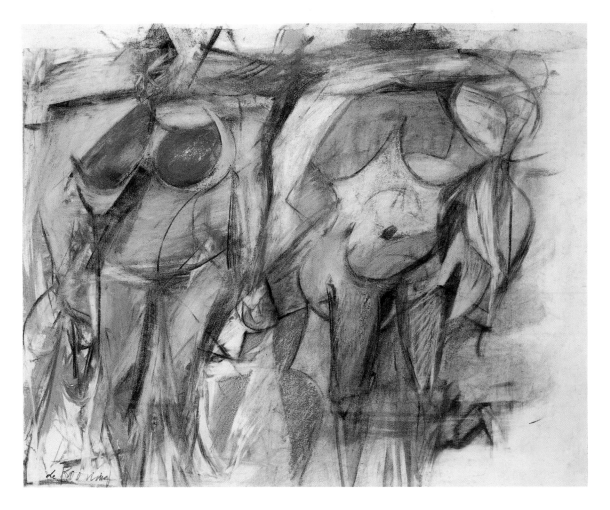

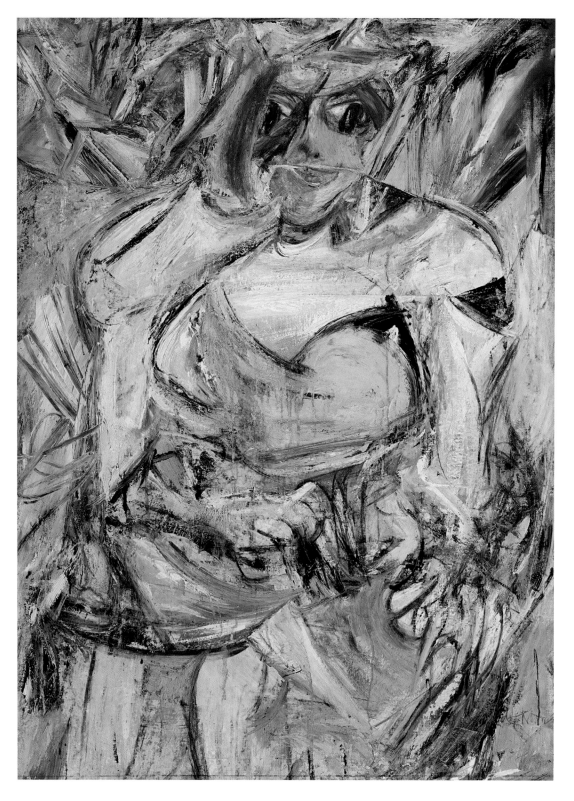

36

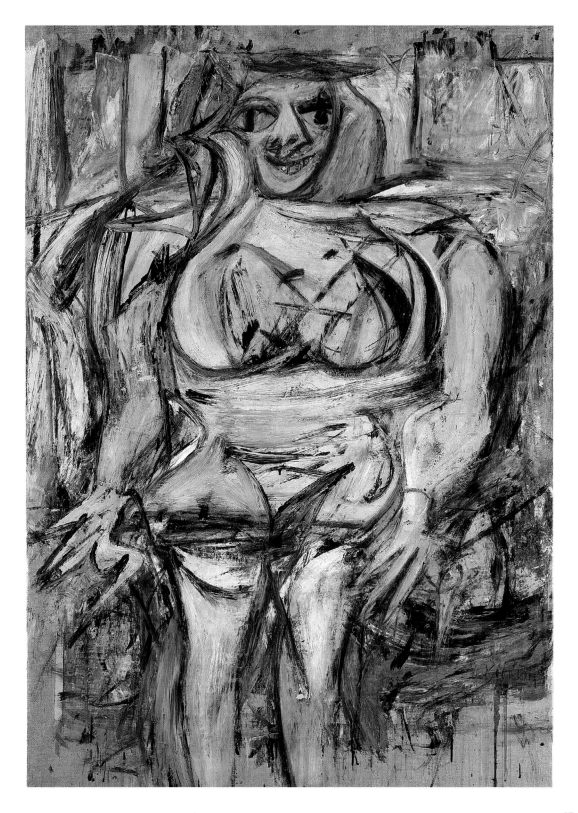

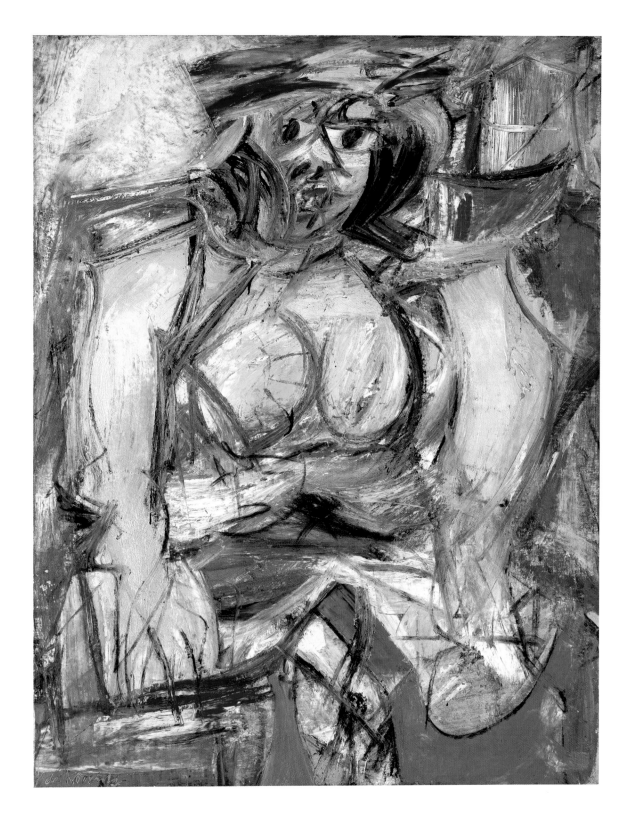

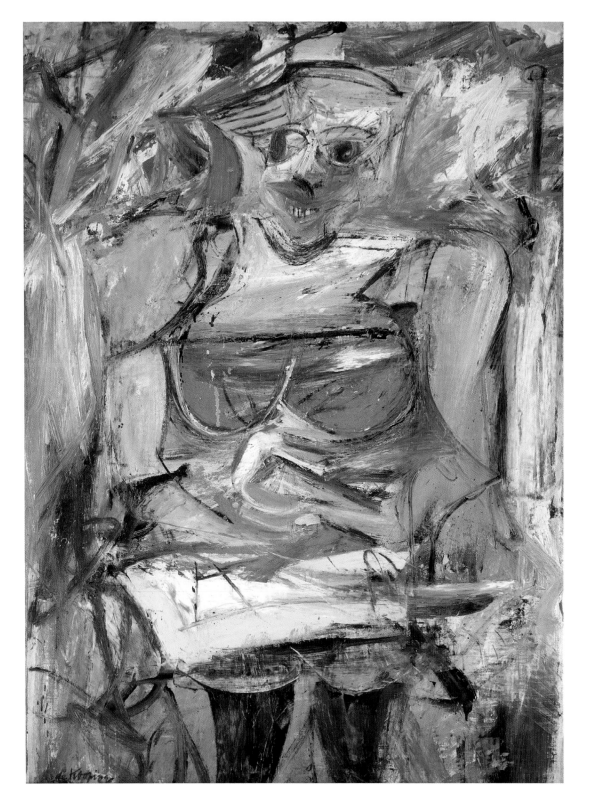

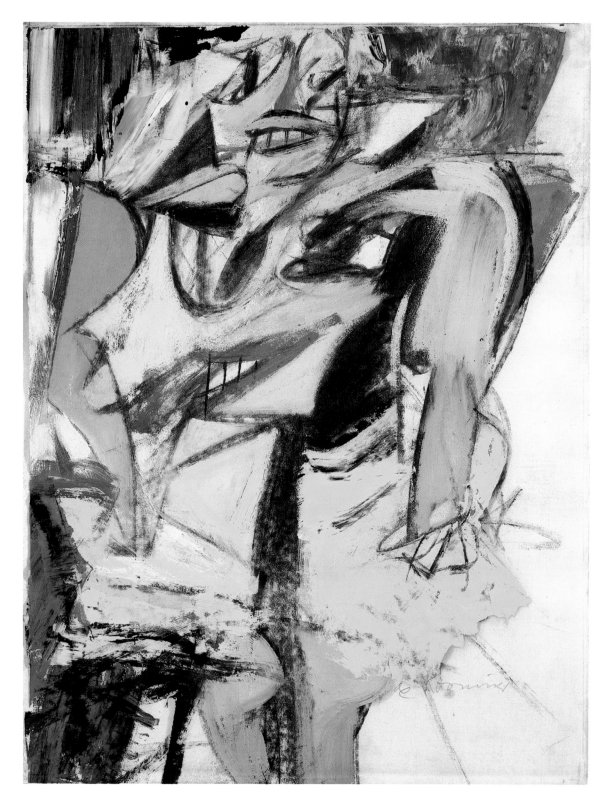

Monumental Woman, 1954
Charcoal on paper, 72.7 x 57.2 cm
Private collection

residence of the dealer Leo Castelli in East Hampton, where *Woman I* was in large part executed (p. 31). The photo reproduces a stereotype: the wife sitting in the background, the husband standing in the foreground and exuding self-confidence. Such photographs were instrumental in shaping the public image of the two artists, and attest to the effort the couple invested in this aspect of their careers. There are photographs of about the same date of Elaine de Kooning in her studio, where she appears to be alone. Here, in contrast, she seems to pose as an adjunct to her husband, the male artist, as if to attest to his heterosexuality, a not unimportant factor in view of the then-frequent press accusations regarding the supposedly high rate of homosexuals in contemporary art. Aside from embodying the appealing look that advertising had since made familiar, the lovely woman forms a striking contrast to the *Woman* image.

De Kooning himself commented on the aspect of sexual identity which many viewers found in the *Women* series. In a 1956 conversation with Selden Rodman, he suggested, "Maybe in that earlier phase I was painting the woman in *me*. Art isn't a wholly masculine occupation, you know. I'm aware that some critics would

ILLUSTRATION TOP:
Elaine de Kooning
Portrait of Harold Rosenberg, 1952
The Estate of Elaine de Kooning

ILLUSTRATION BOTTOM:
Elaine de Kooning
Pencil Drawing of Thomas B. Hess, 1956
The Estate of Elaine de Kooning

ILLUSTRATION PAGE 43:
Two Women, 1951
Pastel on paper, 54.6 x 44.5 cm
Collection of Steve Martin

take this to be an admission of latent homosexuality. If I painted *beautiful* women, would that make me a nonhomosexual? I like beautiful women. In the flesh; even the models in the magazines. Women irritate me sometimes. I painted that irritation in the *Women* series. That's all."

During the period in which de Kooning, despite doubts and setbacks, produced the series *Women I–VI*, the critic Harold Rosenberg was working out a new image of the artist that reflected the existential struggle of Abstract Expressionists acting out their lives in the face of the canvas. "The act-painting is of the same metaphysical substance as the artist's existence. The new painting has broken down every distinction between art and life," declared Rosenberg in December 1952 in *ARTnews*. The investment of physical and emotional energy in the process of making, the expression of force allied with continual control over such "creative outbursts," would come to figure as the essential traits of the Abstract Expressionism of the New York School. This aspect of modern art was in turn associated with familiar notions of "masculinity" – toughness, daring and an aggressiveness that swept the board free of the old and outmoded.

Among the key forums where the Abstract Expressionists – a male group apart from a few women – met and furthered their careers were the Eighth-Street Club, later known simply as The Club, and the Cedar Tavern. The Club was established in late autumn 1949, in a loft at 39 East Eighth Street. Besides de Kooning, the eighteen founding members included Franz Kline and Ad Reinhardt. Until its dissolution in 1962, The Club was frequented by distinguished curators, dealers, collectors and critics, who gathered at the colloquia, concerts and discussion evenings regularly held there. If discussions at The Club primarily revolved around its members' status in art and their potential group identity, the Cedar Tavern was a place where – abetted by alcohol – a cult of masculinity was celebrated. It was an ordinary bar whose proprietor wanted no art hung on the walls, where the competitive atmosphere of an arena often reigned. "We'd be sitting at a table," de Kooning recalled an incident involving Jackson Pollock in an interview with James Valliere in 1967, "and some young fellow would come in. Pollock wouldn't even look at him, he'd just nod his head – like a cowboy – as if to say, 'fuck off.' That was his favorite expression – 'fuck off.' It was really funny, he wouldn't even look at him. He had that cowboy style. It's an American quality with artists and writers. They feel that they have to be very manly."

De Kooning once told David Sylvester, "When I was a child I was very interested in America; it was romantic … cowboys and Indians. … Now that is all over. It's not so much that I'm an American: I'm a New Yorker." Despite his enthusiasm for life in Manhattan, where he moved into a bigger, better lighted studio on Broadway in 1958, from the early 1950s onwards he frequently commuted between New York and Long Island, to the summer houses or residences of dealers such as Leo Castelli and Ileana Sonnabend or of fellow artists like Jackson Pollock and Lee Krasner. Impressions of the landscape alongside the highways, along with the feeling of leaving the city or returning to it, flowed into a series of paintings done in the late 1950s. In large-format canvases such as *September Morn* (p. 46), a preoccupation with the human figure gave way to a gestural abstract approach in broad brushstrokes that, by comparison to the finely articulated, repeatedly reworked *Women*, give the impression of a liberation.

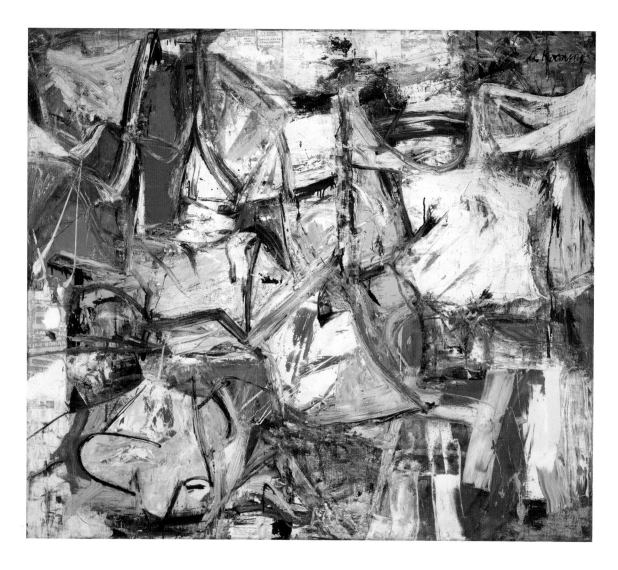

Gotham News, 1955
Oil, enamel and charcoal on canvas,
176.5 x 202.6 cm
Buffalo, New York, Albright-Knox Art Gallery

ILLUSTRATION PAGE 45:
Easter Monday, 1955–56
Oil and newspaper transfer on canvas, 243.8 x 187.9 cm
New York, The Metropolitan Museum of Art. Rogers Fund, 1956 (56.205.2)

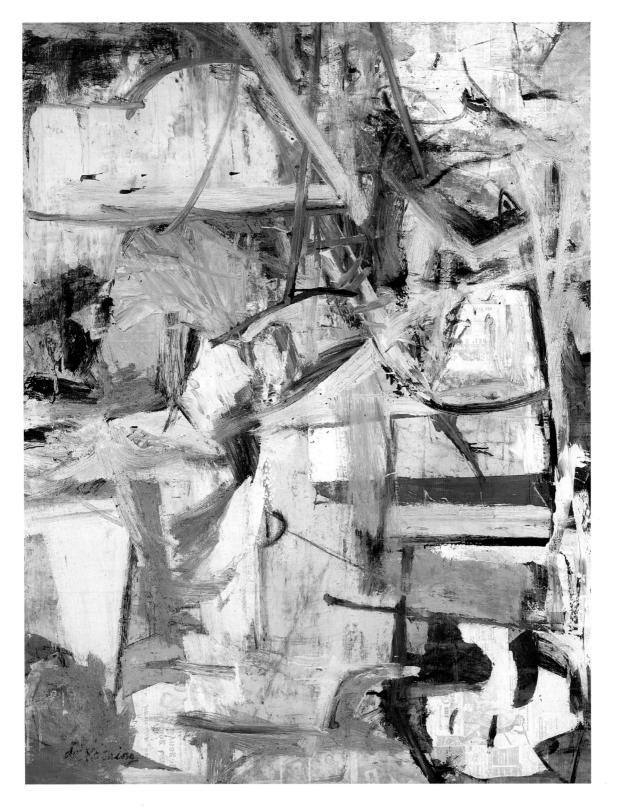

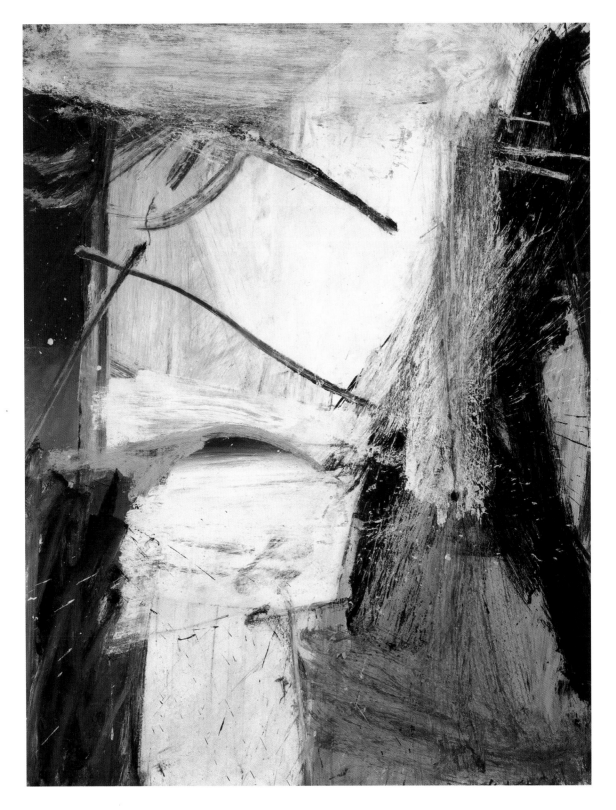

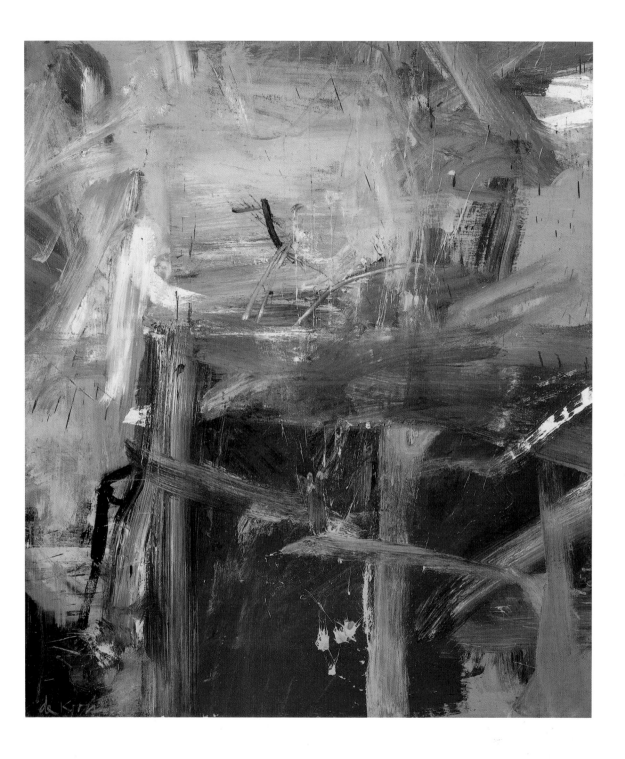

ILLUSTRATION PAGE 46:
September Morn, 1958
Oil on canvas, 160 x 125.7 cm
Private collection

Palisade, 1957
Oil on canvas, 200.7 x 175.3 cm
Private collection

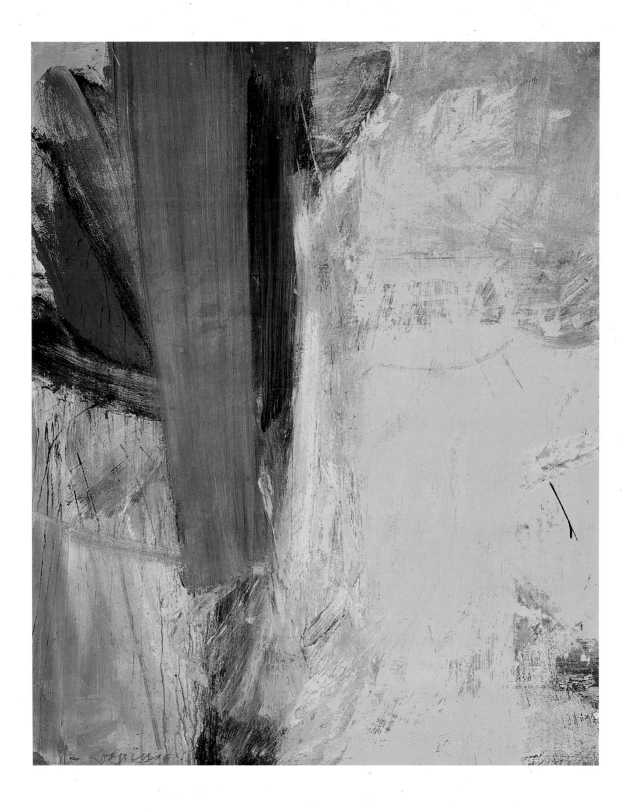

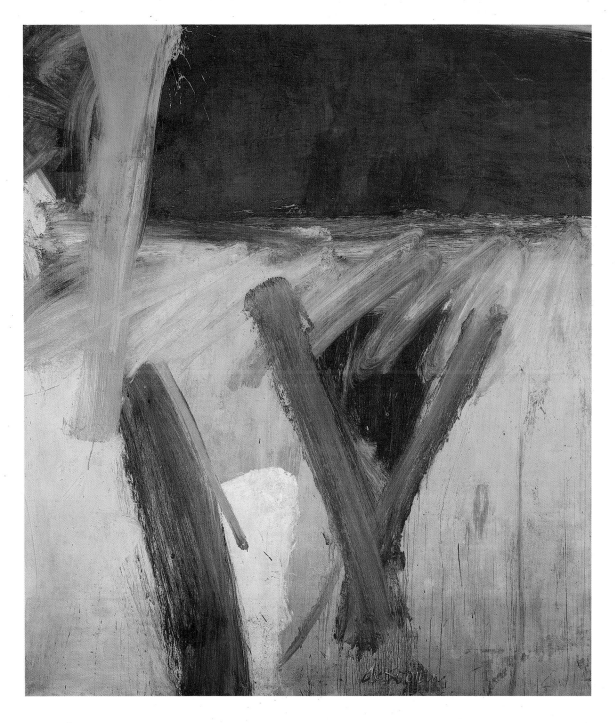

Suburb in Havana, 1958
Oil on canvas, 203.2 x 177.8 cm
Private collection

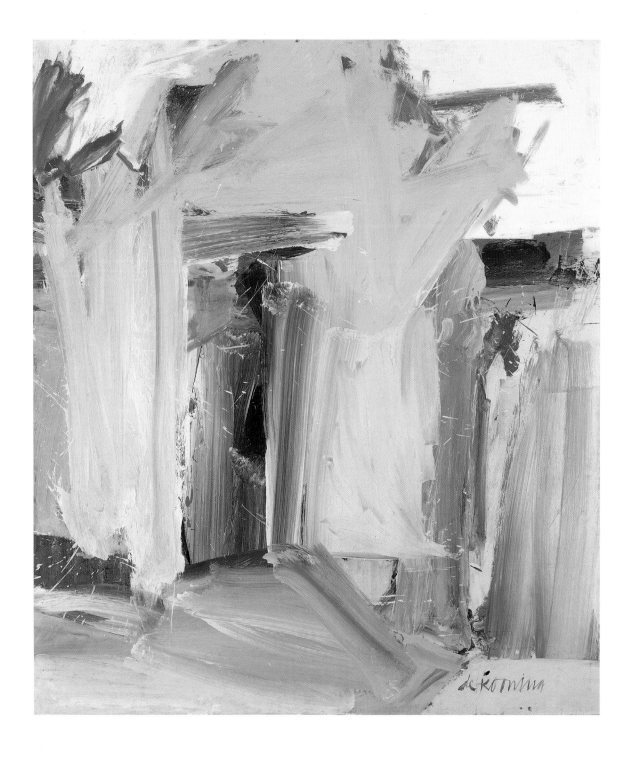

De Kooning in East Hampton: Almost a Pastorale

In 1961 the art critic Robert Rosenblum published a lyrical article, "The Abstract Sublime," in *ARTnews*. In it he compared Mark Rothko's veils of color and Barnett Newman's huge, contemplative color fields to paintings of the Romantic era, such as those of J. M. W. Turner or Caspar David Friedrich's *Monk by the Sea*. According to Rosenblum, American artists had adopted the legacy of European art in the postwar years and had come to play a culturally leading role. "The sublimities of British and German Romantic landscape," averred the critic, "have only been resurrected since 1945 in America, where the authority of Parisian painting has been challenged to an unprecedented degree."

The "sublime" as a term for the human experience of terror and awe in the face of the overwhelming forces of nature had concerned philosophers, poets and aestheticians from the late eighteenth to nearly the end of the nineteenth century. Now, in the wake of World War II and the break with civilization marked by Auschwitz and Hiroshima, a period in which profound doubt was cast on the validity of aesthetic and ethical values, American artists seemed to have linked up with this tradition and translated it into modern terms. The enthusiasm of Rosenblum and others for this new movement in art was clearly motivated by the desire to establish a connection with European traditions. "We ourselves are the monk before the sea," wrote Rosenblum, "standing silently and contemplatively before these huge and soundless pictures as if we were looking at a sunset or a moonlit night."

Towards the end of the 1950s, after his work on the *Women* series, de Kooning turned to landscape motifs, a turn that went hand in hand with a return to radical abstraction. As early as 1954–55 he had painted a canvas with the title *Woman as Landscape*, combining the two subjects with one another. "The pictures done since the *Women*," de Kooning remarked in his 1960 interview with David Sylvester, "they're emotions, most of them." The concept of "landscape" experienced a very personal interpretation in de Kooning's hands, being only very indirectly related to that which presents itself to the eye in the exterior world. What he attempted to do was to capture on canvas fleeting perceptions and sensations, impressions of color and atmosphere. Unlike the renowned landscapists of the nineteenth century, such as Monet or Constable, he did not work outdoors but instead in his studio. In the process, the color range of his palette grew considerably lighter. In pictures like *Door to the River*, 1960 (p. 50) – a strange mixture of

Woman I, 1961
Oil on paper with collage, 73.7 x 56.8 cm
Private collection

ILLUSTRATION PAGE 50:
Door to the River, 1960
Oil on canvas, 203.2 x 177.8 cm
New York, Whitney Museum of American Art.
Purchase, with funds from the Friends of the
Whitney Museum of American Art 60.63

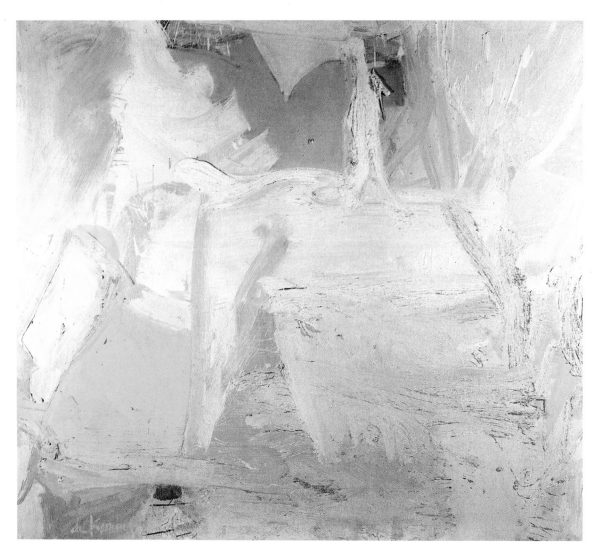

Pastorale, 1963
Oil on canvas, 177.8 x 203.2 cm
Private collection

Pastorale is the last painting de Kooning finished
in New York before settling permanently in The
Springs on Long Island. Although the titles of
works of this period, such as *Pastorale* or *Rosy-
Fingered Dawn at Louse Point* (p. 53), often sug-
gest an ideal and idyllic country life, the artist
himself insisted, "I'm not a pastoral character."

interior and landscape – gradations of yellow and pink cut with a great deal
of white predominate. The composition, built up of a small number of broad,
sweeping strokes, causes our eye to oscillate between an abstract and an objective
reading. What at first appears to be a door leading to a bluish, shimmering river
turns into gestural swathes of paint, and the material quality of the paint itself
dominates the visual impression. Despite the evident change of genre and style,
in his landscape motifs, de Kooning continued his persistent investigation of
painting as a medium.

As early as 1957, with *Palisade* (p. 47), the artist had begun a series that became
known collectively as the "Highway Paintings," and in which figuration was ini-
tially entirely suppressed. In his turn to landscape at this period he focused more
on the transition between big city and its suburbs than on the idyllic country-
side. He was interested in the contrast between rural areas and the urban scene
and its margins marked by expressways and billboards. "I'm not a pastoral char-
acter," de Kooning told David Sylvester. "I am here, and I like New York City. But

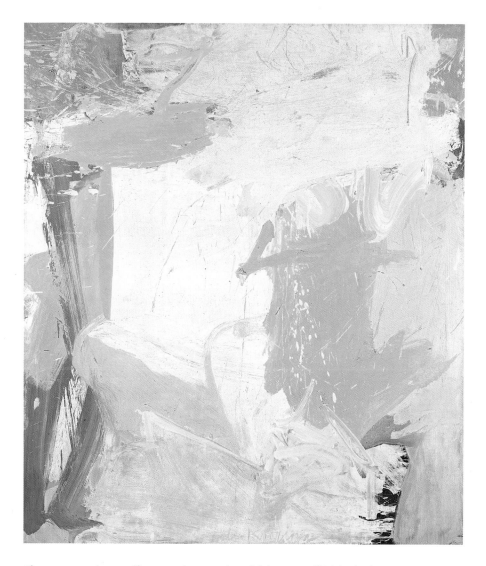

I love to go out in a car. I'm crazy about week-end drives, even if I drive in the middle of the week. I'm just crazy about going over the roads and highways. They are really not very pretty, the big embankments and the shoulders of the roads and the curves are flawless – the lawning of it, the grass. This I don't particularly like or dislike, but I wholly approve of it. Like the signs. Some people want to take the signs away, but it would break my heart. All those different big billboards. There are places in New England where they are not allowed to put those signs, and that's nice too, but I love those grotesque signs." Paintings like *Woman on a Sign II* (p. 58) take up the motifs of such outsized billboards designed to be visually effective when seen from a distance.

Yet it was not his fascination with landscape that motivated de Kooning's move from New York to The Springs on Long Island in the early 1960s. By this time his role as an influential artist on the contemporary scene was long established. The first de Kooning monograph, by Thomas Hess, had appeared in 1959. In 1958–59 pictures of his were included in the international traveling exhibition

Rosy-Fingered Dawn at Louse Point, 1963
Oil on anvasc, 203.2 x 177.8 cm
Amsterdam, Stedelijk Museum

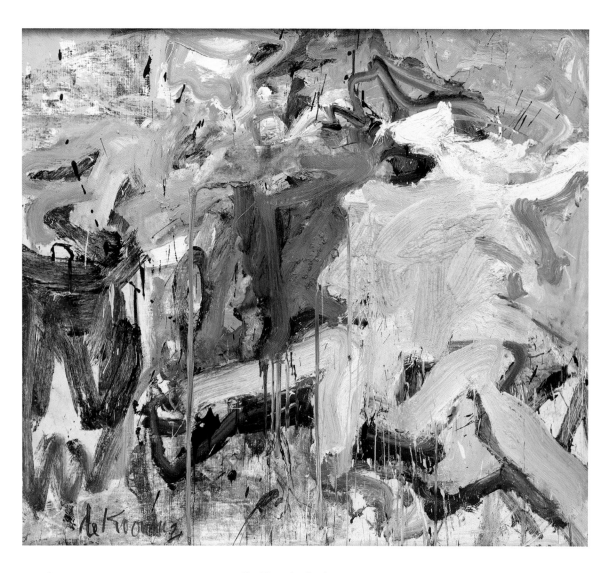

Two Figures in a Landscape, 1967
Oil on canvas, 177.8 x 203.2 cm
Amsterdam, Stedelijk Museum

"The New American Painting," and in 1959 were shown at "Documenta 2" in Kassel, Germany. These presentations established the international leadership of the new American painting. In the meantime, a younger generation of artists came on the New York scene who were soon dubbed the "second generation" of the New York School. Yet the more successful these artists became, the hotter grew the debate on whether or not Abstract Expressionist painting threatened to become academic, a mere modern mannerist style. De Kooning, who in his lecture "A Desperate View" of 1949 had declared style to be a swindle, had himself become an often-copied model ten years later.

At the same time other young artists with a different idea of their metier, and a quite different life-style, were coming to the fore. In the early 1960s, Pop Art began to undermine the predominance of Abstract Expressionism. Its representatives, artists such as Roy Lichtenstein, Andy Warhol, Jasper Johns and Robert Rauschenberg, achieved renown and financial success much more rapidly than the generation of de Kooning, Pollock, Kline and Newman. Lichtenstein, for instance, showed his work to the dealer Leo Castelli in autumn 1961. By February of the next year he already had his first one-man show with Castelli – and it was sold out even before it opened. The rapid rise of Pop contributed to the impres-

Gustave Courbet
The Origin of the World (L'Origine du Monde), 1866
Oil on canvas, 46 x 55 cm
Paris, Musée d'Orsay

Courbet's *L'Origine du Monde* is likely one of his most explicit manifestations of the realism in painting he advocated. The scandalous work was done in 1866 on commission from Khalil Bey, a Turkish diplomat and art collector. In terms of its fixation on the naked female body, the image is comparable to the sexualized poses in some of de Kooning's depictions, such as *The Visit*.

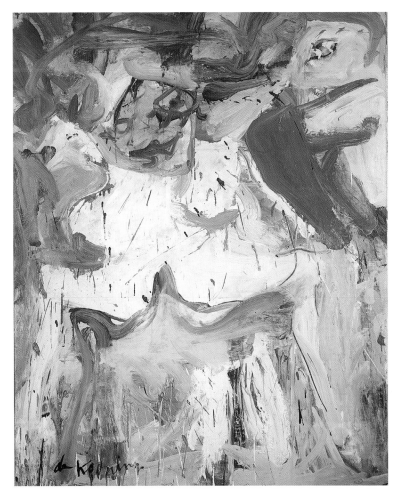

The Visit, 1966–67
Oil on canvas, 152.4 x 122 cm
London, Tate Gallery

sion that Abstract Expressionism was a closed chapter in art history. The artists of this new direction enhanced this development by quoting prominent representatives of the New York School and their painting styles in their work. Around the mid-1960s Lichtenstein painted expressionist brushstrokes in a comic-strip manner – spontaneous, abstract gestures congealed into a mechanical, standardized form, translated into the visual language of a popular mass medium. Sidney Janis, the dealer who in the 1950s had helped de Kooning, Pollock, Mark Rothko and Robert Motherwell to their breakthrough, likewise recognized the signs of the time. On 31 October 1962 he opened "The New Realists," an exhibition devoted to a series of Pop artists, and, like Castelli, began to devote himself entirely to promulgating this new direction in art.

During this transitional phase of the New York and international art scene, de Kooning decided to leave the city. In the summer of 1961 he bought a small country house from his brother-in-law, Peter Fried, in The Springs, East Hampton. In 1963, at age fifty-nine, he left New York for good to live on Long Island. During this period, landscape became his foremost concern. The large-

Reclining Man (John F. Kennedy), 1963
Oil on paper, mounted on fiberboard,
58.4 x 68.6 cm
Washington, DC, Hirshhorn Museum and
Sculpture Garden, Smithsonian Institution.
Gift of Joseph H. Hirshhorn, 1966

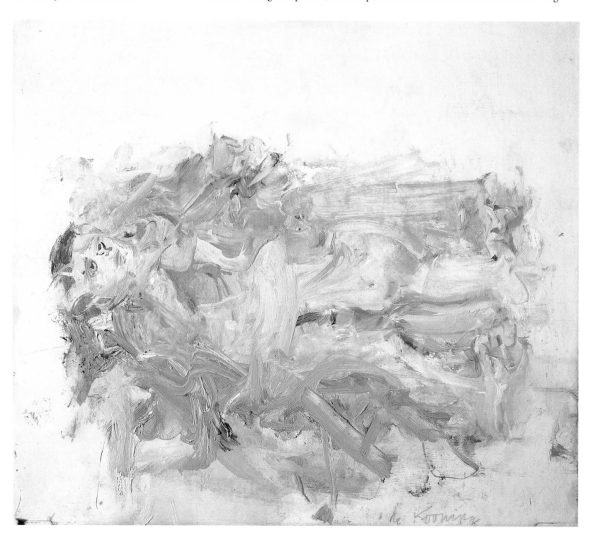

format canvases *Rosy-Fingered Dawn at Louse Point* (p. 53) – a title alluding to the Greek epics of Homer – and *Pastorale* (p. 52) had still been done in de Kooning's New York studio. Especially the latter, with its prevailing pastel pinks and yellows, is often described as his farewell to New York. Its light-saturated colors seem to reflect a city-dweller's idea of sun and ocean, of the vast, wide-open landscape.

De Kooning was fascinated by the surroundings of The Springs, its spreading underbrush and stunted bushes. There, you could still plow the soil, create a place for yourself, as he recalled in a conversation with Harold Rosenberg in 1972. And this is exactly what he did. In winter 1961 de Kooning found a lot near his house that was perfect for a studio. Based on his own designs, in collaboration with the architect Otto Winkler, and with financial aid from his collector, Joseph H. Hirshhorn, the artist erected an atelier. Construction work, which he continually supervised, lasted until 1963 and took up a large part of his time, and his drawing activity came almost to a standstill during these two years. When the studio was finally ready to move in to in March 1964, he initially used it only for work, but a few years later it would also serve as a residence. The building, whose "architecture reminded de Kooning of a ship and had for him, as did East Hampton in general, a 'certain air of Holland about it'," lay near the ocean and, thanks to its open structure and expanse of windows, was flooded with natural light.

After he settled in The Springs, de Kooning's work began to be increasingly shaped by observations made around him: "I reflected upon the reflections on the water, like the fishermen do. They stand there fishing. They seldom catch any fish, but they like to be by themselves for an hour. And I do that almost every day. … There is something about being in touch with the sea that makes me feel good. That's where most of my paintings come from, even when I made them in New York." He began to orient his palette to tones seen in nature, as when he mixed a sand color: "As if I picked up sand and mixed it. And the grey-green grass, the beach grass, and the ocean was all kind of steely grey most of the time. When the light hits the ocean there is a kind of grey light on the water." The gradations of gray and sand color in paintings like *Door to the River* (p. 50), *Pastorale* (p. 52) and *Rosy-Fingered Dawn at Louse Point* (p. 53) were the result of such observations of nature, translated into the language of abstraction.

At about the same time – after the intermission of the "Highway Paintings" – de Kooning returned to images of women, a concern that would continue into the 1970s. In *Woman I* (p. 51) it is a photograph of a smiling woman's face cut from a magazine that lends the gestural swathes of paint a potential figurative meaning. The face, especially, suggests a reading of the white brushstrokes as a body and the single red trace of oil paint as blood. By comparison to the female images of previous decades, which frequently alluded to historical patterns – from prehistoric idols and Renaissance madonnas down to female nudes by Jean-Auguste-Dominique Ingres and Picasso – de Kooning's *Women* of the 1960s seemed more strongly influenced by popular culture. In this decade Clement Greenberg's 1940s dictum that ambitious artists could work only in an abstract and by no means a figurative vein, lost its controversial validity. In the art of the 1960s the human body came increasingly into focus in various ways, be it in the shape of Mel Ramos's Pop pin-ups, Bruce Nauman's early films, in which the artist himself acted in front of the camera, or in the sculptural works in latex and other seemingly organic materials by Eva Hesse.

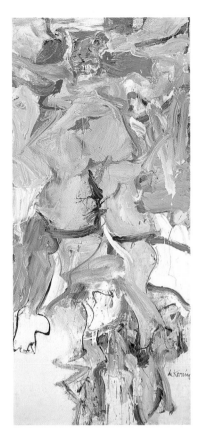

Woman, Sag Harbor, 1964
Oil and charcoal on wood, 203.2 x 91.4 cm
Washington, DC, Hirshhorn Museum and
Sculpture Garden, Smithsonian Institution.
Gift of Joseph H. Hirshhorn, 1966

"I'm working on a water series. The figures are floating, like reflections in the water. The color is influenced by the natural light. That's what is so good here. Yes, maybe they do look like Rubens. Yes, Rubens – with all those dimples … I have to be careful not to make them look too watery."
WILLEM DE KOONING, 1964

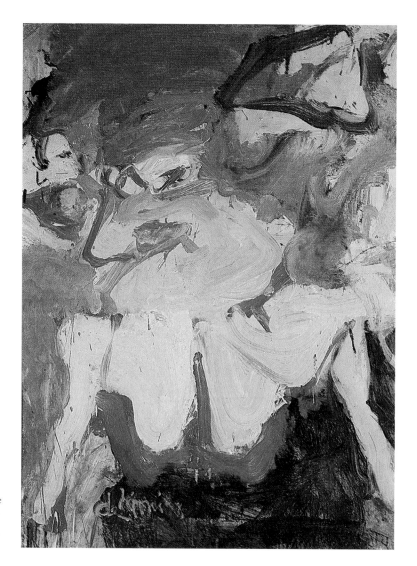

Woman on a Sign II, 1967
Oil on canvas, 142.5 x 105.4 cm
Private collection

Numerous de Kooning works of the 1960s –
like the Pop Art that dominated the interna-
tional scene at the time – made reference to the
imagery of popular culture. In 1967 he began a
series collectively known as *Women on a Sign,*
in which he reacted to fleetingly glimpsed mo-
tifs on roadside billboards.

In 1964 de Kooning developed a new kind of female – and more rarely, male –
body, as in *The Visit* (p. 55), a figure lying on its back with legs spread and knees
raised. De Kooning had begun the painting in winter 1966 and worked on it for
several months. The title goes back to a suggestion of the artist's assistant, John
McMahon, whom the picture reminded of medieval annunciation scenes. It also
brings to mind Gustave Courbet's *The Origin of the World* (p. 55 right) – which
provocatively exhibited what the academic tradition of the nude declared must
remain hidden. De Kooning digested both influences from fine art and popular
culture, but, as he explained in 1964, it was above all the environs of East Hamp-
ton that gave him ideas for new imagery: "Now I go on my bicycle down to the
beach and search for a new image of the landscape. And I love puddles. When I
see a puddle, I stare into it. Later I don't paint a puddle, but the image it calls up
within me. All the images inside me are from nature anyway." De Kooning's
paintings of the period, with their flowing, seemingly unfixed contours, often

conjure up the idea of a blurred mirror image or restless reflections on water. This is also true of a picture that was done in reaction not so much to an experience of nature as to a political event. *Reclining Man (John F. Kennedy)* (p. 56), dated to 1963, evokes a male figure stretched horizontally across the entire format. This is very likely a reference to the assassination of John F. Kennedy, which stunned America in 1963 – a recent interpretation, advanced by art historian Judith Zilczer in 1998 in the journal *American Art,* and based on documentary photographs by Hans Namuth and statements of the artist's friends.

The well-nigh watercolor-like spreading of the colors, their unquiet contours and the evident lack of structure in the figures marked a fundamental difference from de Kooning's best-known works of the 1940s and early 1950s. The *New York Times* critic Hilton Kramer, reviewing a show of de Kooning's East Hampton paintings, was reminded of "an organism consisting of flesh without bones." This "invertebrate quality," in Kramer's opinion, was the price de Kooning paid for his attempt "to banish Cubism as a governing force." Of all directions Cubism appealed to him most, the artist had stated in his 1951 lecture "What Abstract Art Means to Me": "It had that wonderful unsure atmosphere of reflection – a poetic frame where something could be possible, where an artist could practice his intuition." In the 1960s de Kooning experimented with another procedure, one already employed by the Surrealists – *écriture automatique.* This "automatic writing" was an attempt to limit conscious control and give more leeway to intuition and the promptings of the unconscious mind. De Kooning developed a method of working with closed eyes, as he wrote in 1966. Later he would not infrequently encourage intuition by modelling his sculptures wearing two pairs of rubber gloves, as art historian Lynne Cooke reported in 1993.

By the end of the 1960s de Kooning's position on the contemporary art scene had become further consolidated thanks to growing recognition. The Stedelijk Museum in Amsterdam mounted his first exhibition in the Netherlands; this

Untitled, 1964
Charcoal on tracing paper, 47.9 x 60.6 cm
Washington, DC, Hirshhorn Museum and
Sculpture Garden, Smithsonian Institution.
Gift of Joseph H. Hirshhorn, 1966

Montauk I, 1969
Oil on canvas, 223.5 x 195.6 cm
Hartford, CT, Wadsworth Atheneum Museum of Art.
The Ella Gallup Sumner and Mary Catlin Sumner Collection Fund

Montauk IV, 1969
Oil on paper on canvas, 153 x 123 cm
Amsterdam, Stedelijk Museum

"I telephoned de Kooning on a hot day last summer.
'Have you been to the beach?' I asked.
'Oh no, I never go to the beach, especially when there are lots of people here.'
'Watch out, you're turning into a farmer.'
'I don't think so, but one thing – when I see a man of my own age with a bright scarf around his neck speeding by in one of those low-slung cars – I want to kill him!'
'Right,' I said, 'you're a farmer.'
'Well, I know the people here, the ones in the winter; one family has a son in Vietnam …'
And we discussed the war and Bertrand Russell."
THOMAS B. HESS, 1967

retrospective, organized by the Museum of Modern Art, toured for almost a year through the United States and Europe. In the meantime de Kooning entered uncharted artistic territory by turning for the first time to sculpture. As early as 1949, in his lecture "A Desperate View," he had described the difficult relationship of the modern artist to space: "One is utterly lost in space forever. You can float in it, fly in it, suspend in it and today, it seems, to tremble in it is maybe the best or anyhow very fashionable. The idea of being integrated in it is a desperate idea."

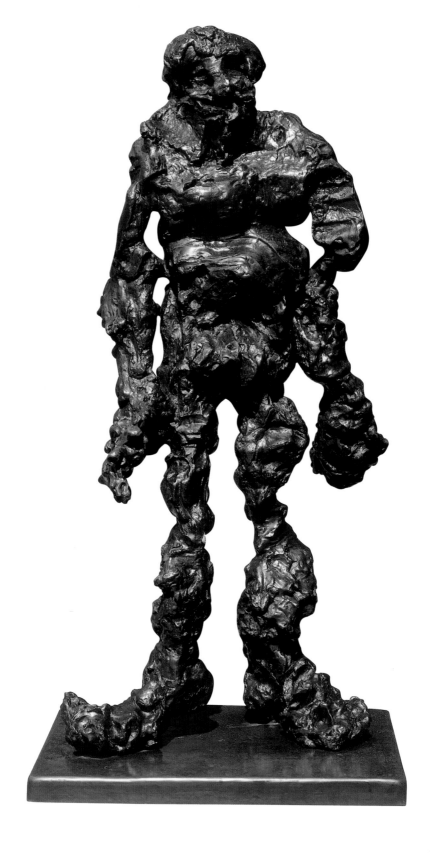

Launching into the Third Dimension: Sculptures

The motifs and titles of the works done on Long Island often refer to the place or situation that inspired them. People digging for clams in the shallow bays near The Springs were a frequent sight. Yet, despite its title, de Kooning's painting *Clam Diggers* (p. 63) shows two nude female figures, rendered in opalescent, shimmering shades of pink and white, which fill the entire picture format – perhaps an allusion to the summer tourism on the island, perhaps also to the ancient goddess of love and beauty depicted standing in an open seashell in Sandro Botticelli's renowned Renaissance painting *The Birth of Venus.* "Recently, de Kooning has taken up the woman again, this time in a relaxed, often roco-co manner," remarked art critic Dore Ashton in 1965. "Boucher, Tiepolo and a host of sensualist painters who celebrated the splendors of the flesh, echo through these largely improvisational works. In a few of the smaller studies, there is a deliberate theatrical atmosphere – the women enter with the studied élan of actresses." In fact de Kooning occasionally recurred in this phase to mass-media images with a theatrical effect designed to capture the viewer's attention. As art historian Richard Shiff pointed out in 1993, at that time his studio contained a news photo of cheerleaders on a basketball court, smiling into the camera. The standing figures in vertical-format pictures like *Woman Accabonac* (p. 64 left), according to Shiff, may well have been inspired by fashion photographs of a type then popular, images taken from a low vantage point of women leaping into the air.

Several work titles of these years contain actual place names, such as *Woman, Sag Harbor* (p. 57) or *Woman Accabonac* (p. 64 left) and *Man Accabonac* (p. 64 right), named after Accabonac Harbor at The Springs. "His real achievement in these later landscapes is the clear description of his own spaces," wrote Ashton. "They are splendid spaces, extending broad and far, dipping back beyond the horizon, inviting the eye to wander." A concern with space – physical space as much as the depiction of space in visual art – can be traced far back in de Kooning's oeuvre and statements. As early as 1949, in his lecture "A Desperate View," he stated that "The idea of space is given him to change if he can. The subject matter in the abstract is *space*." Two years later, in connection with the exhibition "Abstract Painting and Sculpture in America" at the Museum of Modern Art, New York, de Kooning held a talk entitled "What Abstract Art Means to Me." Here he explained his subjective view more succinctly: "That

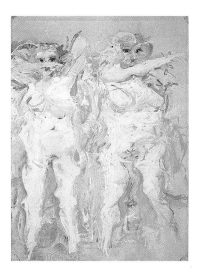

Clam Diggers, 1964
Oil on paper on cardboard, 51.5 x 36.8 cm
Los Angeles, CA, Collection of David Geffen

ILLUSTRATION PAGE 62:
Clamdigger, 1972
Bronze, 151.1 x 75.2 x 60.3 cm
Washington, DC, Hirshhorn Museum and
Sculpture Garden, Smithsonian Institution.
The Joseph H. Hirshhorn Bequest, 1981

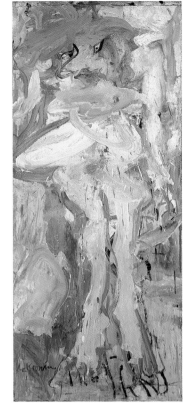
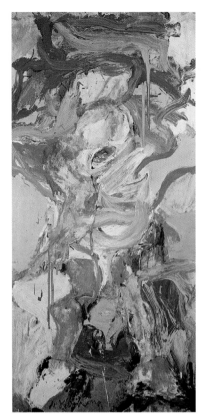

ILLUSTRATION LEFT:
Woman Accabonac, 1966
Oil on paper mounted on canvas,
200.7 x 88.9 cm
New York, Whitney Museum of American Art.
Purchase, with funds from the artist and
Mrs. Bernard F. Gimbel 67.75

ILLUSTRATION RIGHT:
Man Accabonac, 1971
Oil and paper on canvas, 178 x 91 cm
Private collection

ILLUSTRATION PAGE 65:
Cross-Legged Figure, 1972
Bronze, 62.2 x 45 x 40.6 cm
Private collection

space of science – the space of the physicists – I am truly bored with by now. Their lenses are so thick that seen through them, the space gets more and more melancholy. There seems to be no end to the misery of the scientist's space. All that it contains is billions and billions of hunks of matter, hot or cold, floating around in darkness according to a great design of aimlessness. … If I stretch my arms next to the rest of myself and wonder where my fingers are – that is all the space I need as a painter."

This definition of space, determined by the dimensions and actions of the body, can also be seen in the agitated surfaces of de Kooning's sculptures, which he often modeled with his eyes closed. Their shapes bear deep traces of the artist's hands, which appeal just as much to the viewer's sense of touch as to the eye. And just as occasionally applied the paint to canvas with his bare hands, de Kooning's sculptures reflect the physical investment in the creation of a work of art that was characteristic of numerous representatives of Abstract Expressionism. Art historian Claire Stoullig went so far as to see in de Kooning's sculptures a double of himself, a projection of his own body. The lumps of clay out of which he built his organic figures even reminded her of macerated chicken droppings.

Back in the 1950s, in his lecture entitled "The Renaissance and Order," de Kooning had described the fascination with the flesh he had observed in the work of Renaissance artists. Their interest in the difference between various textures – silk, wood, velvet, glass, marble, he stated, consisted only in *their*

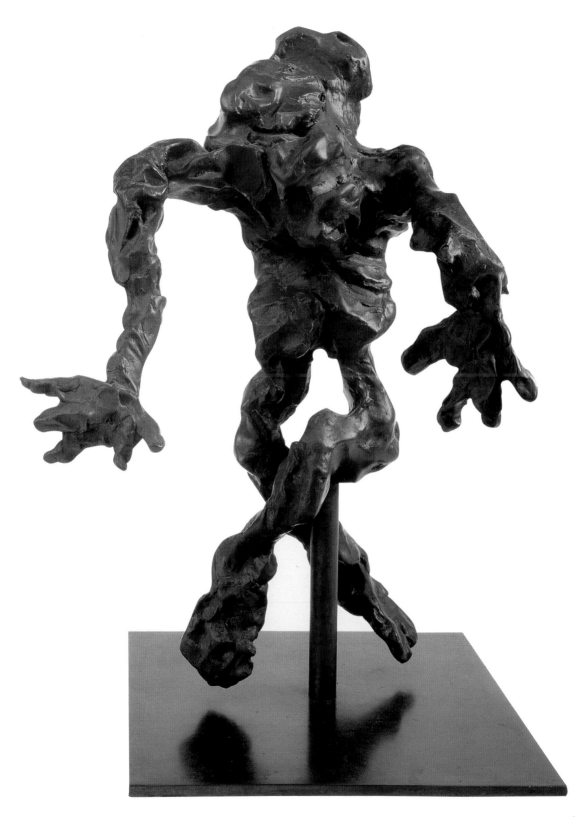

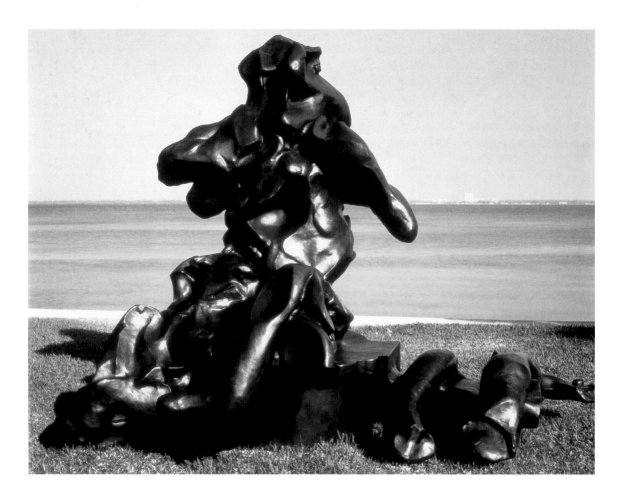

ILLUSTRATION TOP:
Seated Woman, 1969–80
Bronze, 287 x 373.4 x 238.8 cm

ILLUSTRATION BOTTOM:
Untitled #12, 1969
Bronze, 16.5 x 21.5 x 14 cm

connection with flesh. His famous declaration that flesh was the reason oil painting was invented could be applied just as well to his sculptures. They seem to investigate and reflect the qualities of flesh, its elasticity and malleability as much as the ever-present threat of dissolution and decay, its transitory nature. For de Kooning the sculptures – akin to fetishes – appeared to possess a kind of life of their own, even a consciousness of their own existence. "That is why," the artist declared in "The Renaissance and Order," "I think Giacometti's figures are like real people. The idea that the thing that the artist is making can come to know for itself, how high it is, how wide and how deep it is, is a historical one – a traditional one I think. It comes from man's own image." Another inspiration for his sculptures, according to de Kooning, came from the French painter Chaïm Soutine: "I've always been crazy about Soutine – all of his paintings. Maybe it's the lushness of the paint. He builds up a surface that looks like a material, like a substance. There's a kind of transfiguration, a certain fleshiness in his work."

It was a trip to Italy in summer 1969 that marked the beginning of de Kooning's work in sculpture. During a stay in Rome he met a friend, the sculptor Herzl Emanuel, and in his studio began experimenting for the first time with clay. The first small sculptures that emerged from these attempts were

no larger than a hand, having been formed of clay lumps that were easy to grasp and manipulate. When larger formats were involved, as art historian Lynne Cooke pointed out in 1993, de Kooning would wear several pairs of rubber gloves, in order to enlarge and alienate the imprints of his fingers. This procedure, inspired more by the plastic material itself than by any model – whether live model or existing sculpture – was characteristic of de Kooning, and differed from the methods used by other "painter-sculptors," such as Edgar Degas or Henri Matisse. Yet if de Kooning was far from the naturalistic precision of a Degas, who clad his bronze ballerina figures in real tulle tutus, he nevertheless concerned himself with the motif of dancing figures who defied the force of gravity. Despite its massiveness, the figure in *Cross-Legged Figure* (p. 65), with its arms thrown back and floating hair, possesses an extremely vital élan.

Bronze castings of the clay figures were made in Emanuel's foundry. A few of the small-format bronzes, such as *Untitled #6* (p. 68), were three-dimensional correspondences to the oil renderings of figures reclining on their back with spread, bent legs that de Kooning had produced since 1964. At the same time, this sculpture calls to mind a piece by the French sculptor Auguste Rodin, a nude female figure grasping her right foot with her right hand and arching her torso seemingly to the breaking point. Just as in de Kooning's *Untitled #6* and a few related works, the body of Rodin's *Iris, Messenger of the Gods* (p. 69 bottom) is fragmentary.

In January 1968 de Kooning made his first trip to Paris. It is conceivable that he was confronted there with Rodin's works, which he had almost certainly already seen in reproductions. After all he described himself as an "eclectic painter" who was always susceptible to inspiration from reproductions of art, no matter from what era. In a conversation with Harold Rosenberg he quoted the painter Edouard Manet and admitted that "every time I put my hands in my pockets, I find someone else's fingers there." Soon de Kooning was combining the malleable clay material with ordinary found objects. In *Untitled #12* (p. 66 bottom), for instance, he used an electric socket as a kind of seat.

Again in 1969, after initially concentrating in Rome on a group of small-format sculptures, de Kooning began – purportedly on the advice of the English sculptor Henry Moore, among other reasons – to attempt to cast enlargements, but then decided to work directly on a larger scale instead. In the early 1980s, however, he did execute a monumental, almost three-meter tall version of *Untitled #12* (p. 66 bottom) with the title *Seated Woman* (p. 66 top). The piece confronts the viewer with an eerie presence, as if modeled by a giant's hand. The great enlargement simultaneously enables us to view the surface treatment, the finger imprints, bulgings and squeezings of the clay, as if through a magnifying glass.

With his sculpture *Clamdigger* (p. 62), de Kooning returned in the early 1970s to a motif familiar from his paintings. The nearly lifesize freestanding figure was not an enlargement of a smaller sculpture but was created directly out of a manipulation of the material. Thanks to its agitated surface, the figure seems to "tremble" restlessly in space, as de Kooning had once remarked, instead of being "integrated" into it. It seems not so much to be searching the mud of the bay for clams as to have just emerged from the ooze itself. In the sculpture, de Kooning built up the shape piece by piece, using viscous, almost fluid clay. If his idol Alberto Giacometti could ask himself how much material he could remove from a sculpture and still maintain the impression of a figure,

Willem de Kooning working on *Clamdigger*, 1972
Photograph by Hans Namuth

"When Bill first started sculpting with clay, he was interested in the imprint the hands made and the muscularity of their movement shown in the clay. And sometimes he went from two dimensions to three dimensions in his sculpture. He would draw a figure on a flat piece of plywood. His assistant, David Christian, cut the drawing out of the plywood. Bill would decide which side would be the front and which side would be the back. David would attach a pipe to the back to hold the piece upright on a stand. Then they added a wire-mesh armature and Bill would start applying the clay and working with it."
ELAINE DE KOONING, 1982

de Kooning seems to have asked himself the opposite – how much material he could pile on without the figure's reverting to an amorphous lump of clay. The *Clamdigger* (p. 62) gives the impression of a figure existing in a desolate intermediate state, not yet finished or already half destroyed. The cavernous eye sockets recall a skull. *Clamdigger* was followed by a series of slightly over lifesize heads, partly fragmentary or forced into planarity. With their gaping mouths and protruding or sunken eyeballs, these bear no individual traits but convey a general impression of existential despair.

From the early 1960s onwards de Kooning – now renowned worldwide – apparently began to see his fear of failure in a more philosophical light than in the previous decade. In a conversation with David Sylvester he self-ironically spoke of having with time "developed a little culture for [himself], like yoghurt; as long as you keep something of the original microbes, the original thing in it will grow out." What evidently fascinated de Kooning about sculpture was that it could not be taken in with a single glance. This, in turn, increased the difficulty, in the process of making a sculpture, of deciding when it was finished. In de Kooning's career it was often external circumstances, such as an imminent

Untitled #6, 1969
Bronze, 19 x 25.4 x 5.7 cm

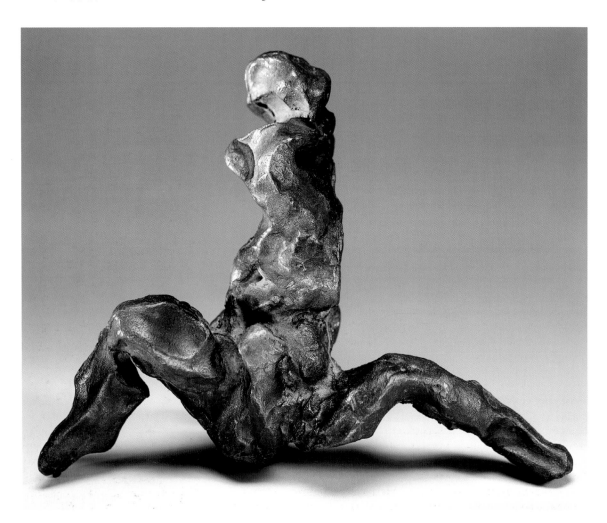

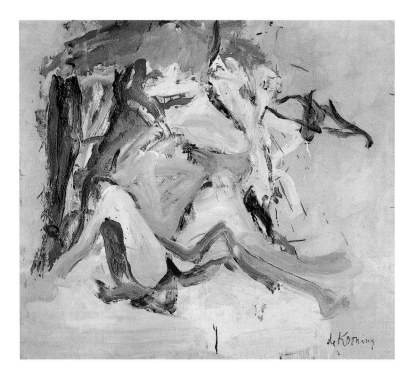

Woman on the Dune, 1967
Oil on paper on canvas, 122.6 x 138.4 cm
Canada, Collection of Marielle L. Mailhot

exhibition opening, that led him to accept a work as finished. When his fellow artist Robert Motherwell asked him, in 1950, how he knew a picture was finished, de Kooning replied, "I refrain from 'finishing' it. I paint myself out of the picture, and when I have done that, I either throw it away or keep it. I am always in the picture somewhere. The amount of space I use I am always in, I seem to move around in it, and there seems to be a time when I lose sight of what I wanted to do, and then I am out of it. If the picture has a countenance, I keep it. If it hasn't, I throw it away."

In later years he would describe the impossibility of deciding when a work was finished in more general and radical terms. With regard to the medium of sculpture, he explained to Harold Rosenberg in 1972, "Most things in the world are absolutes in terms of taking someone's word for it. For example, rulers. But if you yourself made a sphere, you could never know if it was one. . . . That's what fascinates me – to make something I can never be sure of, and no one else can either. I will never know, and no one else will ever know. That's the way art is."

With his figurative bronze sculptures, which occupied him for a limited time, de Kooning took an outsider's position in the art of the late 1960s and early 1970s. The three-dimensional objects of Pop Art largely focused on trivial consumer goods and things from the mundane world. With Minimal Art, a new direction was established that devoted itself to objects on the borderline between image and sculpture in space, and employed anonymous industrial materials and means of production, as well as a geometric formal language. Conceptual Art, on the other hand, frequently dispensed with the making of objects entirely, usually reducing the material presence of the work of art to documentations in photo and text. Nevertheless, as critic Dore Ashton under-

Auguste Rodin
Iris, Messenger of the Gods, 1890
Bronze, 48.5 x 39.5 x 23 cm
Paris, Musée Rodin

The French sculptor Auguste Rodin sparked controversy among his contemporaries with the extreme naturalism of his figures. In 1877 he was accused of employing casts taken from living models as the basis of his bronzes. In his figure of Iris, a messenger of the gods in Greek mythology, Rodin departed from tradition by depicting her without wings.

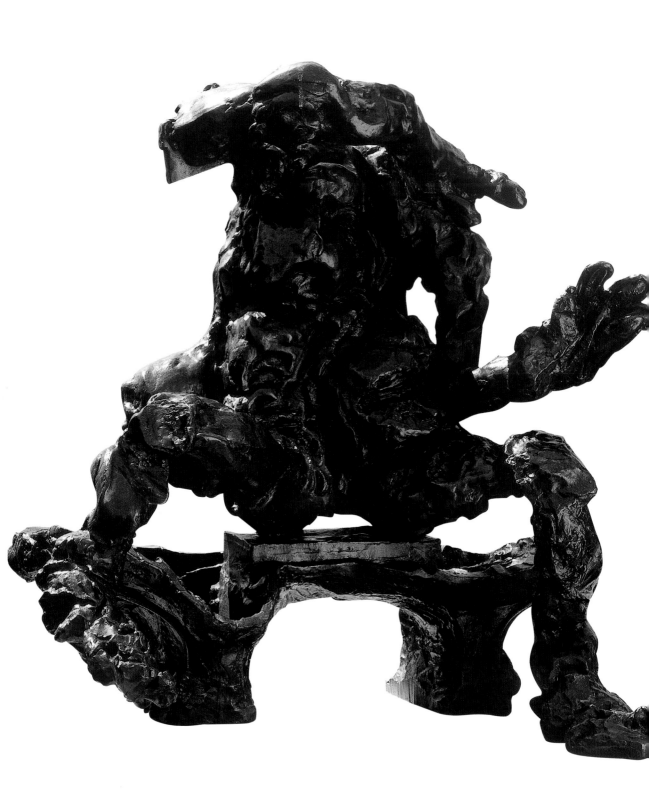

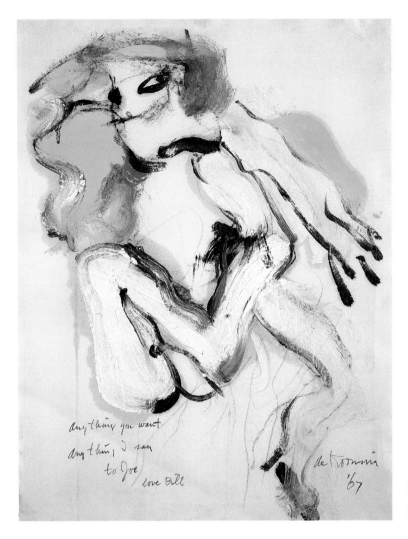

any thing you want
any thing I say
to Joe
love Bill

Untitled, 1967
Oil and charcoal on paper, 61.1 x 46.4 cm
Washington, DC, Hirshhorn Museum and
Sculpture Garden, Smithsonian Institution.
The Joseph H. Hirshhorn Bequest, 1981

scored, de Kooning exerted considerable influence on developments in con-
temporary art: "He has restored the possibility of dealing with the human fig-
ure, opening the way to a host of younger artists." In the late 1970s and early
1980s de Kooning's works would indeed inspire a younger generation of artists
and help trigger a boom in neoexpressive figurative art.

ILLUSTRATION PAGE 70:
Seated Woman on a Bench, 1972 (cast 1976)
Bronze, 95.9 x 91.9 x 87.4 cm
Washington, DC, Hirshhorn Museum and
Sculpture Garden, Smithsonian Institution.
The Joseph H. Hirshhorn Bequest, 1981

In making large-scale sculptures like *Seated
Woman on a Bench*, de Kooning used to wear
several pairs of rubber gloves, one over the
other, as an aid to helping him model the clay
in a more generous and less detailed way. In
parallel he experimented with new materials
such as polyester resin.

Between Remembering and Forgetting: Late Paintings, the 1970s and 1980s

In 1983 or 1984, as the artist's eightieth birthday approached, Erwin Leiser, a German documentary filmmaker, visited Elaine and Willem de Kooning in his studio residence in The Springs. By this point de Kooning, said Leiser, was "the last survivor" of the first generation of the New York School. Arshile Gorky had died in 1948, Jackson Pollock in 1956, Franz Kline in 1962, Stuart Davis in 1964, David Smith in 1965 and Mark Rothko in 1970, to mention only a few of its best-known representatives, who belonged to de Kooning's circle of acquaintances. In several scenes that run like leitmotifs through his 1984 film, Leiser shows de Kooning at work on a large-format abstract canvas; unlike previous years, in early 1983 he began working only on a single picture at a time, leaving it on the easel until it was finished. As he is painting he continually glances aside, towards a number of other pictures that apparently serve as points of departure or orientation for the emergent work. In the 1980s this procedure led to veritable suites of paintings. Using a broad flat brush, de Kooning would trace on a light-colored ground the contours of abstract forms, principally in the primary colors of yellow, red and blue. The forms appear biomorphically sweeping, yet no longer call up associations with organs separated from the body as did his early, Surrealist-inspired abstractions of the 1940s, such as *Pink Angels* (p. 10) or *Still Life* (p. 23). Occasionally the artist would rub the palm of his hand over the transitions between the colored areas and the ground, blending the edges and engendering a smooth, unified surface on which traces of separate brushstrokes were no longer visible. Thanks to their feathered edges, the forms appear to float on the picture surface, and the blurred paint suggests a slight motion, as if the shapes were swirling or eddying in space. In compositions from the middle of the 1980s, such as *Untitled XIII* (p. 72), these bandlike forms occasionally congeal into closed, sweepingly interlocking color fields.

This on first glance so sparing use of pictorial elements on a light ground reminded more than one critic of Henri Matisse's late cut-outs, created on his sickbed in the early 1950s. During de Kooning's long career he concerned himself time and again with the French artist's work, after having been deeply impressed by a Matisse show in 1927, at the Dudensing Gallery in New York. After long considering Picasso a prime rival, the man to beat, he later discovered in Matisse's paintings an apparent ease and facility that he wished to emulate. When we compare de Kooning's paintings of the 1980s to those of earlier decades with their

De Kooning at work, 1983

ILLUSTRATION PAGE 72:
Untitled XIII, 1985
Oil on canvas, 203.2 x 177.8 cm
Cleveland, OH, The Cleveland Museum of Art.
Leonard C. Hanna, Jr., Fund, 1987.63

73

Landscape of an Armchair, 1971
Oil on canvas, 203.3 x 177.8 cm
Private collection

The title *Landscape of an Armchair* links two
different genres of art, landscape and interior.
Towards the end of the 1960s, in parallel with
the emergence of his first sculptures, the figura-
tive allusions in de Kooning's paintings again
began to grow increasingly vague.

heavy, repeatedly reworked paint layers, they appear surprisingly smooth and
relatively simple in composition. It would appear that de Kooning strove above
all for formal equilibrium; the manipulated paint itself seems to represent the
principal "content" of these works. "Content," the artist had emphasized back
in the early 1960s, "is a glimpse of something, an encounter like a flash. It's very
tiny – very tiny, content."

However, the formal reduction of these compositions belies the quite com-
plicated process by which they were made. Just as Rudolph Burckhardt had
photographically recorded the months of work on *Woman I* thirty years before
(p. 34), de Kooning's assistant, Tom Ferrara, now documented fourteen stages
in the emergence of *Untitled XXIII*. In subsequent years, however, de Kooning
would begin to reduce the number of working steps and to rotate the canvas
on the easel less often – a procedure he had used for years, which is recorded in
Erwin Leiser's film. After having worked on a canvas for some time, the artist
would rotate the canvas by ninety degrees with the help of a pivoting easel, con-
sider its effect from a distance, and then proceed to work on the picture from this
new angle. Thomas Hess, back in 1959, had described de Kooning's painting as
"a slippery universe made of expanding numbers of indications and changing
points of view – a finished painting is turned upside-down at the last moment,
an eye becomes a tack, a thumb becomes a mountain."

Woman in the Water, 1972
Oil on canvas, 151.2 x 137.2 cm
U. S. A., Collection of Gertrude and Leonard Kasle

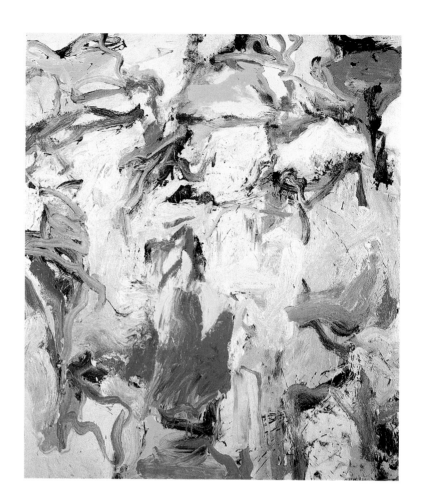

Untitled I, 1975
Oil on canvas, 203.3 x 177.8 cm
Private collection

Around 1983, de Kooning, to use his own phrase of 1950, began to "paint himself out of the picture" more rapidly. This change in procedure went hand in hand with an enormous increase in productivity. Between 1980 and 1987 he produced over three hundred paintings. During the most intensive phase, from 1983 to 1986, he even finished a picture a week – a remarkably high output, especially for an artist who was famous for considering his works finished only with the greatest hesitation. "[De Kooning] knew his days were dwindling," Tom Ferrara explained, "and he was propelled. He was not struggling. He wasn't trying to prove anything. He was just doing. It became like breathing. He just breathed them out."

The unusually productive 1980s had been preceded by a period of personal and creative crisis. De Kooning's paintings of the 1980s might never have been done, summed up art critic Robert Storr in 1995, on the occasion of the first museum retrospective of these works. It was common knowledge that since the 1970s the artist had been increasingly suffering from the consequences of alcoholism – a fate and illness that was not unique to him, for it affected many artists of his generation. Pollock had died in an automobile accident in 1956 when drunk at the wheel; Rothko had suffered in the 1960s from the consequences of alcohol and cigarette abuse. The social ritual of drinking bouts at The Club and

the Cedar Bar went back to the 1950s, when the New York School artists' improving financial situation enabled them to proceed from coffee to alcohol. Moreover, a befriended doctor had recommended at the time that de Kooning take a little brandy in the morning for "therapeutic reasons," to help him overcome his feelings of anxiety and self-doubt with regard to his art. It was a dangerous cure, which dampened his debilitating panic attacks at the price of increasing dependence. By the end of the 1970s the state of de Kooning's health had gravely worsened, threatening to bring his artistic activity to a standstill. At this point in time, Elaine de Kooning resumed contact with him.

The couple had separated in 1955, though they had never divorced. Elaine de Kooning had made a name for herself as an artist and critic, and had taught at several universities, including the University of New Mexico in Albuquerque and the University of California at Davis. In 1975 she had bought a house in East Hampton, Long Island, and settled there. Three years later, after having over-

...Whose Name Was Writ in Water, 1975
Oil on canvas, 195 x 223 cm
New York, The Solomon R. Guggenheim
Museum 80.2738

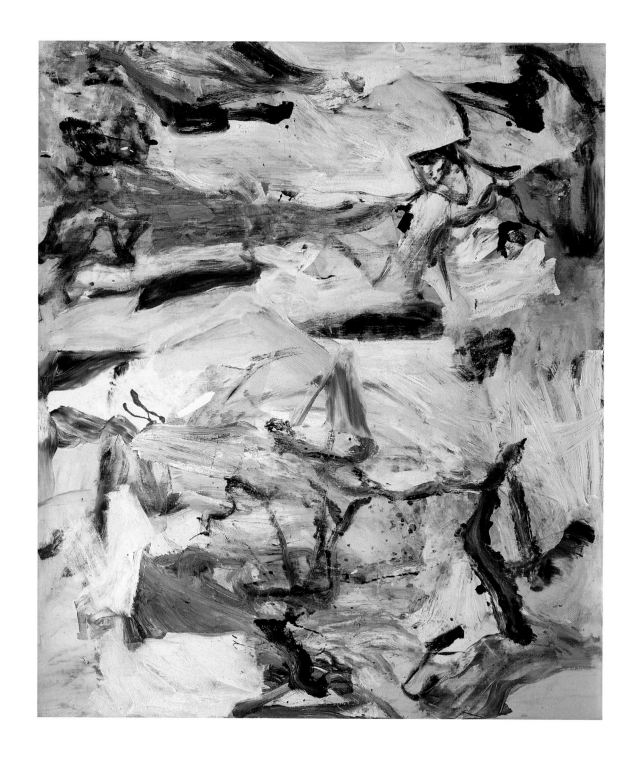

Untitled XVIII (North Atlantic Light), 1977
Oil on canvas, 203.2 x 177.8 cm
Amsterdam, Stedelijk Museum

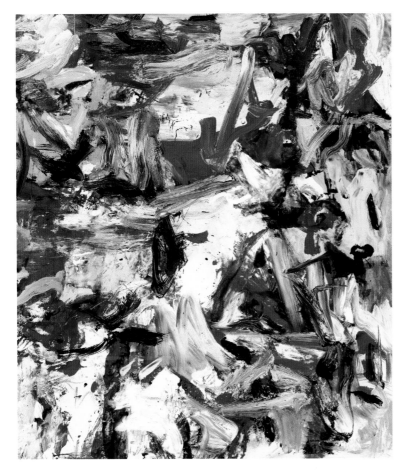

Untitled XIX, 1977
Oil on canvas, 202.6 x 177.8 cm
New York, The Museum of Modern Art.
Gift of Philip Johnson

The abbreviated brushstrokes and indeterminate space of de Kooning's paintings of the late 1970s, such as *Untitled XIX* and *Untitled XVIII (North Atlantic Light)* (p. 78), evoke an atmosphere that cannot be traced back to any definite, identifiable location. The American art historian Diane Waldman has compared them to the late work of Claude Monet.

come her own alcohol problem, she began to bring order into her husband's life and work again. Her energetic efforts are credited with having convinced him to undergo withdrawal treatment and ensured that he remained abstinent after 1980. The preconditions essential to his further development had been established.

"I have to change to stay the same," de Kooning once reportedly said about himself. His development was shot through with abrupt changes of course. De Kooning's final phase, described by art historian Gary Garrels as "lyrical abstraction," began in 1981, with *Pirate (Untitled II)* (p. 80). Here the paint application has a transparent, smooth appearance, with expansive areas of white and yellow that lend the composition luminosity. The title suggests a reference to de Kooning's late friend, Arshile Gorky, who had taken his own life in 1948. Two of Gorky's paintings of 1940 bore the same title. However, de Kooning himself did not attach much importance to picture titles at any point in his career, and occasionally accepted suggestions made by others. In the present case, as Tom Ferrara later reported, the billowing white shape in the middle of the canvas reminded the artist of the sail of a pirate ship, giving rise to the now accepted title.

Compared to the airy compositions of the 1980s, de Kooning's paintings of the late 1970s seem to reflect a *horror vacui*. They evince a veritably baroque

Pirate (Untitled II), 1981
Oil on canvas, 223.5 x 194.9 cm
New York, The Museum of Modern Art.
Sidney and Harriet Janis Collection Fund

Untitled III, 1981
Oil on canvas, 223.5 x 195.6 cm
Washington, DC, Hirshhorn Museum and Sculpture Garden, Smithsonian Institution.
Partial Gift of Joseph H. Hirshhorn, by exchange, and Museum Purchase, 1982

Untitled XII, 1982
Oil on canvas, 177.8 x 203.2 cm
New York, Heyman Collection

abundance of forms and a lavish employment of oil paint. In this period the significance of line and graphic elements that characterized de Kooning's works of the 1940s and 1950s made way for a dominance of painterly handled color. Objective, figurative references and allusions – still detectable in paintings of the early 1970s, such as *Landscape of an Armchair* (p. 74) and *Woman in the Water* (p. 75) – increasingly dissolved into a pure evocation of atmosphere. For this reason pictures from the middle of the decade, such as *Untitled I* (p. 76), were often compared to the late paintings of the Impressionist Claude Monet, inspired by his garden in Giverny. The motif of water surfaces with their restless reflections of light and color, which had preoccupied de Kooning especially after his move to The Springs, reappeared in a composition like ...*Whose Name Was Writ in Water* (p. 77) – an unusually literary title by de Kooning's standards. The phrase can be traced back to a seventeenth-century play, a quotation from which the English poet John Keats, who died of tuberculosis in 1821 at age twenty-five, selected as the epitaph for his gravestone: "Here lies one whose name was writ in

Morning: The Springs, 1983
Oil on canvas, 203.2 x 177.8 cm
Amsterdam, Stedelijk Museum

Untitled XXIII, 1982
Oil on canvas, 203.2 x 177.8 cm
Private collection

Untitled III, 1983
Oil on canvas, 223.5 x 195.6 cm
San Antonio, TX, Courtesy SBC Communications Inc.

Untitled VII, 1985
Oil on canvas, 177.8 x 203.2 cm
New York, The Museum of Modern Art.
Purchase and gift of Milly and Arnold Glimcher

water." The trembling, interrupted lines in de Kooning's picture call to mind letters losing their shape and beginning to dissolve. Not only do these echo the letters in his paintings of the 1940s and 1950s, such as *Zurich*, 1947, or *Easter Monday* (p. 45), but also point back to the artist's early training as a sign painter and window-display designer.

Distant reminiscences played an important role, especially in his late work. In Leiser's film de Kooning explained that the yellow in the picture that stood on the easel reminded him of the facade of the Rotterdam department store where he had worked as assistant to the art director in the 1920s. The title *… Whose Name Was Writ in Water* (p. 77) might be seen to reflect de Kooning's worsening health and his sense of impending death, that is, as a sort of *vanitas* motif. Yet it could just as well be read as a deprecating reference to the fact that by this time he had become a living legend. In 1974 the Australian National Gallery in Canberra had acquired de Kooning's *Woman V* (p. 39) for 850,000 dollars – the highest price yet paid for the work of a living American artist. Further records followed. At an auction in the early 1980s *Two Women* (p. 43) would fetch the highest sum ever paid at auction for a work by any living artist of the postwar period – 1.21 million dollars.

It was not until 1995, in an exhibition that traveled to venues in the United States and Europe, that de Kooning's late work was presented to the public in a comprehensive manner. Yet, it was a presentation to which the artist was not able actively to contribute. He suffered from a loss of memory that grew increasingly worse towards the end of the 1980s, causing the periods during which he was capable of working to become shorter and shorter. Finally, in 1989, he was diagnosed as suffering in all probability from Alzheimer's disease. After Elaine de Kooning's death in February 1989, the artist's daughter, Lisa de Kooning, and John L. Eastman were granted guardianship over Willem de Kooning. In the summer of 1990 he entered his studio to paint for the last time.

This meant that the art historians who prepared the exhibition of 1980s works mentioned above faced the challenge of making a legitimate selection from de Kooning's extensive oeuvre of that decade without the artist's help. They had to decide, for instance, which of the unsigned pictures could be considered finished. Since the mid-1970s de Kooning had been in the habit of signing his works not on the front but on the back of the frame – and that generally not until the work was on the verge of leaving the studio. A distinguished commission of experts were moreover confronted by the task of putting an end to speculations about de Kooning's late work. This included the question of how to estimate, in view of the artist's illness, the contribution that his assistants had made to it. Art historians Gary Garrels and Robert Storr aimed at dispelling these misgivings in two ways.

First of all, they conducted interviews with those involved, hoping to shed more light on the working procedures followed in de Kooning's studio. In the 1970s, rejected and unfinished canvases were sanded down for reuse. The first canvases used in the 1980s were left over from the 1970s. The "ghosts" that remained on the smooth surface provided impulses for a new image. Yet always, even when a new canvas was undertaken, a drawing formed the point of departure. In this regard de Kooning again and again returned to techniques he had already used back in the 1930s and 1940s. Apparently the assistants hired by Elaine de Kooning and her brother, Conrad Fried – above all Tom Ferrara and Robert Chapman – were primarily responsible for encouraging the artist to work when depression had robbed him of motivation. In the mid-1980s de Kooning

Woman, 1983
Charcoal on white paper, 146 x 98 cm
Cologne, Museum Ludwig

Untitled II, 1986
Oil on canvas, 223.5 x 195.5 cm

The Cat's Meow, 1987
Oil on canvas, 223.5 x 195.6 cm
Private collection

‹no title›, 1987
Oil on canvas, 195.6 x 223.5 cm
Private collection

In 1986 the artist Robert Dash asked de Kooning
how he was feeling. He replied, "Pretty good,
still working for the same firm."
WILLEM DE KOONING, 1986

began to start new works with images of drawings projected onto blank canvas-
es. Occasionally one of his assistants would trace the contours of the projected
drawing in charcoal on the blank canvas and fill in the intermediate spaces with
white paint. Assistants were also responsible for preparing the colors, and thus
had a certain influence on the range of de Kooning's palette at the end of the
1980s.

The second thrust of Garrels', Storr's and the other commission members'
efforts was to determine, by an aesthetic analysis of the paintings and their styl-
istic development – including comparisons with the late or mature styles of
other artists, such as Monet, Matisse and Picasso – what paintings could be
considered representative achievements of de Kooning's late phase. They con-
ceived the exhibition as beginning with works of 1981 and ending with works
of 1987. Since that exhibition, curators have begun to exhibit paintings from 1988
as well. In the course of this complicated process, which would make de Koon-
ing's late work accessible to a broad public for the first time, the famous dictum

of Marcel Duchamp – whom de Kooning once admiringly described as a "one-man movement" – once again proved its truth. The viewers of a work of art, Duchamp declared, always contributed to its emergence, since their approval or disapproval helped insure its survival.

‹no title›, 1988
Oil on canvas, 177.8 x 203.2 cm
Private collection

Willem de Kooning 1904–1997
Chronology

If not otherwise indicated, all events listed took place in New York.

1904 April 24: Willem de Kooning is born in Rotterdam, Holland, to Leendert de Kooning and Cornelia de Kooning, née Nobel.

1907 Willem's parents are divorced. His father initially obtains custody of Willem, and his mother custody of his sister, Marie Cornelia (born 1899), but in further court proceedings his mother is granted custody of Willem as well.

1916 Begins four-year apprenticeship in commercial arts and interior decoration at the firm of Jan and Jaap Gidding, Rotterdam.

1917 Attends evening courses at the Rotterdam Academy of Fine Arts and Techniques, until 1921.

1920 Works for Bernard Romein, art director and designer of a Rotterdam department store.

1924 Travels through Belgium. Earns money as window-display decorator and sign painter, among other jobs.

1925 Returns to Rotterdam intending to finish his training at the academy, but does not do so. Decides to emigrate.

1926 Leaves for the United States without papers, working in the engine room of the ship the SS Shelley, which lands in Newport, Virginia. Is hired on to a second ship, which he disembarks in Boston, where he obtains legal papers, then settles in Hoboken, New Jersey, where he works as a house painter.

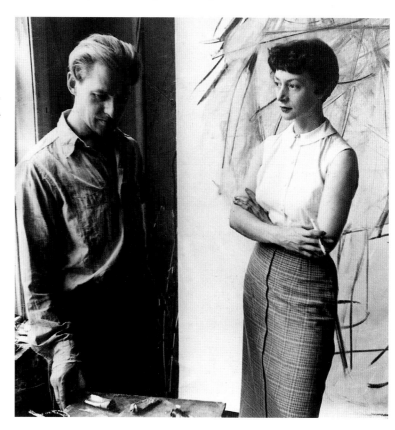

ILLUSTRATION PAGE 92:
Willem and Elaine de Kooning, 1950
New York, the Estate of Rudy Burckhardt

ILLUSTRATION LEFT:
Willem de Kooning, 1953
Photograph by Hans Namuth

1927 Moves to New York.

1929 Meets Stuart Davis and John Graham.

1930–1931 Through John Graham, meets David Smith. Makes friends with Arshile Gorky, who introduces him to the dealer Sidney Janis.

1934 Becomes a member of the Artists' Union.

1935 Receives commissions from the Works Progress Administration (WPA) Federal Art Project, mural division. Prepares designs for the Williamsburg Federal Housing Project, Brooklyn, which, however, are not executed.

1936 In a project headed by Fernand Léger, designs a mural for the French Lines shipping dock, which is never executed. Since he is not an American citizen, de Kooning has to leave the WPA. Beginning of friendship with the photographer Rudolph Burckhardt and the poet and dance critic Edwin Denby, who become his first collectors. At Ibram Lassaw's studio, partici-

pates in discussions that lead to the founding of the artists' association American Abstract Artists (A A A). Meets art critic Harold Rosenberg. Begins to devote himself exclusively to painting; commences a series of paintings of standing and seated male figures (pp. 15–17). First participation in a group exhibition, "New Horizons in American Art," at the Museum of Modern Art.

1937 Receives a commission to design a mural for the Hall of Pharmacy at the 1939 New York World's Fair. The painting is executed by professional muralists. Meets the artists Philip Guston and Barnett Newman, and the art student Elaine Fried, who becomes his pupil.

1938–1944 First *Women* series (pp. 18–19).

1939–1940 Makes the acquaintance of Franz Kline in Conrad Marca-Relli's studio.

1940 Commissioned by Grace and Edwin Denby to design costumes and sets for Nini Theilade's ballet

Les Nuages at the Metropolitan Opera House. Fashion illustrations for *Harper's Bazaar*.

1942 Participates in the group exhibition "American and French Paintings," curated by John Graham for McMillen, Inc. Meets Marcel Duchamp and Jackson Pollock.

1943 Marries Elaine Fried.

1946 Begins series of black-and-white abstractions (pp. 24–25, 28–29).

1947–1949 Second series of *Women* (pp. 30, 32).

1948 With *Mailbox*, 1947, participates for the first time in the "Annual Exhibition of Contemporary Painting" at the Whitney Museum of American Art. First one-man show, at the Charles Egan Gallery. First museum purchase, by the Museum of Modern Art (*Painting*, p. 25). On the invitation of Josef Albers, teaches at Black Mountain College, North Carolina. Makes the acquaintance of the art critic Thomas B. Hess.

1962 March 13: De Kooning obtains U.S. citizenship.

1963 With *Pastorale* (p. 52) completes series of large-format abstract landscape compositions. June: Moves permanently to The Springs.

1964 March: Starts to work in his new studio. Begins painting a series of *Women* on hollow-core doors. Participates with four works in "Documenta III," Kassel, Germany.

1965 First American museum retrospective, at the Smith College Museum of Art, Northampton, Massachusetts. Signs a petition against the Vietnam War in Washington, DC.

1968 January: First trip to Paris. June: Premiere solo exhibition in Europe, at M. Knoedler et Cie., Paris. Meets Francis Bacon in London. September: First journey to Holland since 1926, on the occasion of his retrospective at the Stedelijk Museum, Amsterdam; the exhibition travels to the Tate Gallery, London, and in 1969 to the Museum of Modern Art, New York, the Art Institute of Chicago, and the Los Angeles County Museum.

1969 Travels to Rome, where his first sculptures are executed.

1970 January: Travels to Japan and becomes interested in Japanese drawing techniques.

1970–1971 Creates series of lithographs at the Hollander Workshop, New York.

1974 The Australian National Gallery in Canberra acquires *Woman V* (p. 39), for 850,000 dollars, the highest price yet paid for a work by a living American artist.

1949 Delivers a lecture, "A Desperate View," at The Subjects of the Artists school, from which The Club will soon emerge. Participates with Elaine de Kooning in the exhibition "Artists: Man and Wife," at the Sidney Janis Gallery. Becomes a charter member of The Club.

1950 At Studio 35, Robert Motherwell delivers an oral presentation of de Kooning's essay "The Renaissance and Order," which will be published in 1951 in the journal *trans/formation*. First exhibition abroad, at the twenty-fifth Venice Biennale, of works selected by Alfred H. Barr, Jr., director of the Museum of Modern Art. Begins third *Women* series (pp. 33–43). On the invitation of Josef Albers, teaches at the Yale School of Fine Arts and Architecture, New Haven, Connecticut.

1951 De Kooning's essay "What Abstract Art Means to Me" is published in the *Bulletin of the Museum of Modern Art*. Participates in the group exhibition "Ninth Street Show," curated by Leo Castelli. Elaine and Willem de Kooning are summer guests at Ileana and Leo Castelli's home in East Hampton, Long Island.

1952 Summer stay in East Hampton with Ileana and Leo Castelli.

1953 One-man show, "Paintings on the Theme of the Woman," at the Sidney Janis Gallery. The Museum of Modern Art acquires *Woman I* (p. 6).

1955 Commences series of abstract cityscapes (pp. 44–45). Begins to combine the motifs of woman and landscape. Separates from Elaine.

1956 Daughter Johanna Liesbeth (Lisa) born to Joan Ward.

1957 Begins series of abstract landscapes (pp. 46–50, 52, 53).

1959 Represented with five works at "Documenta II," Kassel, Germany.

1961 Purchases a house in The Springs, East Hampton, Long Island. Plans to build a studio house on the adjacent lot. Works in The Springs and New York City.

1978 Elaine de Kooning, who had bought a house in East Hampton in

1975, resumes daily contact with her husband.

1983 At Christie's, *Two Women* (p. 43), realizes the largest sum ever paid at auction for a work by a living artist of the postwar period – 1.21 million dollars.

1989 February 1: Elaine de Kooning dies of lung cancer in Southampton. As de Kooning is no longer able to manage his business affairs, Lisa de Kooning and John L. Eastman petition the New York Supreme Court to become conservators of the property of Willem de Kooning and are appointed to this function. November: *Interchange*, 1955, is sold at auction by Sotheby's for 20.8 million dollars, another record price for the work of a living artist.

1997 March 19: Willem de Kooning dies at his home in East Hampton, New York.

ILLUSTRATION PAGE 94:
Willem de Kooning, 1964
Photograph by Hans Namuth

ILLUSTRATION LEFT:
Willem de Kooning, 1968
Photograph by Hans Namuth

ILLUSTRATION BELOW:
Willem de Kooning, 1983
Photograph by Hans Namuth

Bibliography

Thomas B. Hess: *Willem de Kooning*. New York, 1959.

Thomas B. Hess: *Willem de Kooning*. Exh. cat., The Museum of Modern Art, New York, 1968.

Thomas B. Hess: *Willem de Kooning: Drawings*. New York, 1972.

Harold Rosenberg: *Willem de Kooning*. New York, 1974.

Willem de Kooning: Skulpturen. Exh. cat., Josef-Haubrich-Kunsthalle, Cologne, 1983.

Willem de Kooning: The North Atlantic Light 1960–1983. Exh. cat., Stedelijk Museum, Amsterdam, 1983 (and further venues).

Paul Cummings, Jörn Merkert and Claire Stoullig: *Willem de Kooning: Retrospektive. Zeichnungen, Gemälde, Skulpturen*. Exh. cat., Akademie der Künste, Berlin, 1984 (and further venues).

Edwin Denby: *Willem de Kooning*. New York, 1988.

Diane Waldman: *Willem de Kooning*. New York, 1988.

Marla Prather: *Willem de Kooning: Paintings*. With essays by David Sylvester and Richard Shiff. Exh. cat., National Gallery of Art, Washington, 1994 (and further venues).

Judith Zilczer: *Willem de Kooning from the Hirshhorn Museum Collection*. With essays by Lynne Cooke and Susan Lake, and correspondence between Willem de Kooning and Joseph and Olga Hirshhorn. Exh. cat., Hirshhorn Museum and Sculpture Garden, Smithsonian Institution, Washington, 1993 (and further venues).

Willem de Kooning: The Late Paintings, the 1980s. With essays by Gary Garrels and Robert Storr. Exh. cat., San Francisco Museum of Modern Art, San Francisco, 1995 (and further venues).

Willem de Kooning: Tracing the Figure. With essays by Cornelia H. Butler, Paul Schimmel, Richard Shiff und Anne M. Wagner. Exh. cat., The Museum of Contemporary Art, Los Angeles, 2002 (and further venues).

Photo Credits